The Campus History Series

STATE UNIVERSITY OF NEW YORK AT COBLESKILL

ON THE COVER: Students and faculty spend time outside after graduation on the Old Quad in the 1920s. In the founding years of the school, students helped with construction, farm work, and daily chores of the college. Today, whether it is in the barns, or out on an internship, students experience both theoretical teaching and hands-on application, in and out of the classroom. (Courtesy of the State University of New York at Cobleskill.)

The Campus History Series

STATE UNIVERSITY OF NEW YORK AT COBLESKILL

STATE UNIVERSITY OF NEW YORK AT COBLESKILL
ALUMNI ASSOCIATION

ARCADIA
PUBLISHING

Published by Arcadia Publishing
Charleston, South Carolina

Printed in the United States of America

Library of Congress Control Number: 2014957377

For all general information, please contact Arcadia Publishing:
Telephone 843-853-2070
Fax 843-853-0044
E-mail sales@arcadiapublishing.com
For customer service and orders:
Toll-Free 1-888-313-2665

Visit us on the Internet at www.arcadiapublishing.com

To the men and women who built a college and a community; who taught, learned, and lived at SUNY Cobleskill—faculty, staff, and students, past and present; to all those who made our history memorable and our future possible, this book is gratefully dedicated.

CONTENTS

ACKNOWLEDGMENTS

This book would not have been possible without the dedication of many individuals. Thank you to all who helped make this possible.

We would first like to thank Anne Myers, professor emerita, for her generous contributions to the narrative and writing of this book. Photograph sorting was undertaken by the following emeriti and retirees: Anne Donnelly, Francine Apollo, Lucy McKelvy, MacDonald Holmes, Harald Abrahamsen, Thomas Bowes, Michael Montario ('62), Anne Myers, and Effie Bennett – Powe. Katie Kolger Ali ('10) was involved in the previous timeline project, which supplemented the book. Mitch Tomaszkiewicz contributed to the book's athletic history. Jessica Travis ('14) wrote the introduction. The following alumni and advancement office staff contributed to caption organization and writing: Emma Tiner ('15), Sabrinna Hansen ('15), and Kate Weaver ('04). Lois Goblet ('79) developed the concept for the book. Further photographic identification was undertaken by the following: Kayla Vaughn, Ray Roes ('76), and Larry Van Deusen ('74). Special thanks go out to the following for their time and dedication to this project: Mohamed Baligh ('12), Jennifer Schorf, Brandon Aldous ('14), Dottie Wilcox ('01), Amy Healy, Debra Thatcher, and Karen Speenburgh ('99).

This book would not be possible without the perseverance of Matthew Barney who worked tirelessly in leading the final compilation of text and photograph selection. His perspective and appreciation for photographic detail were essential to the completion of this publication.

All images are from the archives of the State University of New York at Cobleskill.

INTRODUCTION

As the State University of New York College of Agriculture and Technology at Cobleskill approaches its 100th anniversary in 2016, it is essential that the history of such a metamorphic institution be shared. A state university with humble beginnings, this emerging leader in agricultural and experiential education embraces a rich past—a past that provides the fundamental pieces in creating its extraordinary future.

The college, which began as an experimental alternative secondary school with a very narrow mission, was designed to appeal to young men who dropped out of high school and were solely interested in agriculture. Now, 100 years later, it is a comprehensive university granting both associate and bachelor degrees in academic areas such as agricultural business, animal science, applied psychology, biotechnology, business, communications, culinary arts, early childhood, financial planning, fisheries and wildlife, and graphic design. What began with one building and eight students now has over 70 buildings and 2,500 students.

Each of the three chapters of this book encompasses a distinct time period in the history of the State University of New York at Cobleskill. Unfolding throughout this book is an archive of past and present images, collectively depicting an educational institution dedicated to moving forward.

The first chapter introduces the early years of the college (1916–1929). The Schoharie State School of Agriculture, the university's initial name, was originally created for young men who were not interested in completing high school. It was, in fact, an early example of what is now New York State's Boards of Cooperative Educational Services. An experiment the state was willing to invest in, the Schoharie State School of Agriculture opened its doors in 1916. Tuition was free, and students had only to show completion of eighth grade and be 16 years of age.

The middle years (1930s–1970s) are covered in the second chapter. This era welcomed great development. As the number of students, the number of buildings, and the impression of the campus on surrounding communities grew, the transition into a state college offering associate degrees followed. It was also during these years that Cobleskill began to excel in athletics, winning a number of conference championships. Additionally, the college implemented a chapter of Phi Theta Kappa, thanks to Dr. Elbridge Smith. The Orange Key Club was established, exemplifying the spirit of the college as students were nominated by faculty and staff, not just on merit of their scholarship, but on their service to the campus and the community.

As described in chapter three (1980s–present), the State University of New York at Cobleskill has persistently sought to develop in ways that benefit its students, faculty, staff, and other

members of the campus and surrounding community. Though the path of growth includes great triumphs and inevitable challenges, the college continues to maintain its mission: to provide students with practical learning alongside theoretical knowledge. As a result of the university's determination to consistently move forward, this time period comprises many monumental accomplishments and advances. These include the emergence and continued diversity of baccalaureate programs, a steady rise in international students and programs, and the renovation of several areas on campus, including the original campus arrangement, currently referred to as the "Old Quad."

Today, the college continues to move forward. Visitors to campus will witness a remarkable transformation. On the central mall, which has undergone re-landscaping, flags are displayed from of all the countries that have sent students here. A new Center for Environmental Science and Technology gives students and faculty space to experiment on new technologies. State and private grants will fund a new dairy-processing center, returning the campus to its roots, when students made ice cream and other dairy products and assisted other agricultural entrepreneurs in early success. But perhaps the clearest symbol of remarkable progress is the new Center for Agriculture and Natural Resources, which graces the north side of campus and overlooks the rest of the college. Standing five floors high, the center is technologically advanced and student friendly, with spaces for interaction with faculty and other students. Like the college it represents, it embraces the future, but it has not forgotten the best of its past.

One

PLANTING SEEDS
A NEW KIND OF EDUCATION

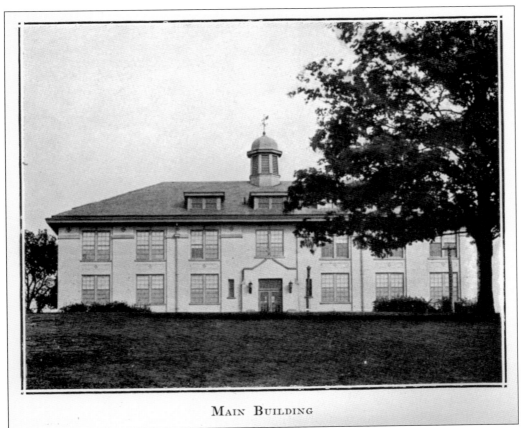

MAIN BUILDING

Main Building was erected in the summer of 1916 and opened as the first structure of the Schoharie State School of Agriculture. It was renamed Frisbie Hall in 1932 in honor of Assemblyman Daniel Dodge Frisbie, who passed away the previous year.

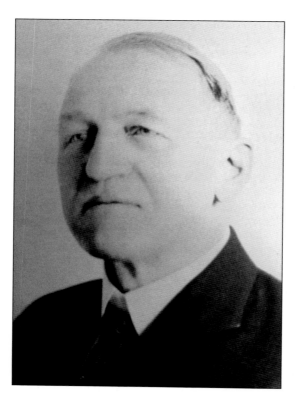

Daniel Dodge Frisbie of Middleburgh, New York, was the Speaker of the New York State Assembly in 1911. He is credited with championing the state appropriation used to construct the Schoharie State School of Agriculture, which ultimately became SUNY Cobleskill. He was also the owner of the *Schoharie Democratic Republican*, a countywide newspaper popular in the late 19th and early 20th centuries.

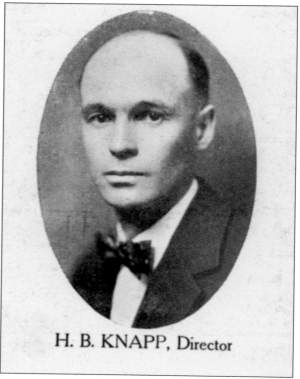

H. B. KNAPP, Director

Hailing from Ithaca, New York, Dr. Halsey B. Knapp served as the first director of the Schoharie State School of Agriculture, from 1916 to 1923. SUNY Cobleskill's current administrative building, Knapp Hall, is named for him. Notably, Dr. Knapp is the only individual to have buildings carry his name on two separate SUNY campuses, as he was also instrumental in the development of Farmingdale State University on Long Island.

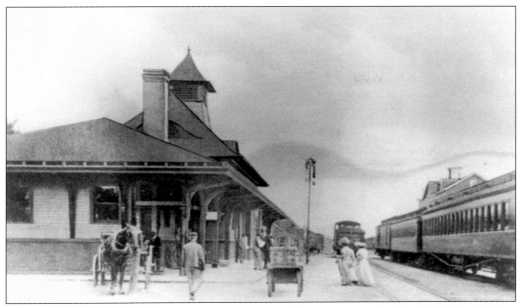

The Delaware & Hudson Railroad station is seen here sometime before 1920. Dr. Halsey B. Knapp arrived at the station from Ithaca in 1916 to visit what would one day become the SUNY Cobleskill campus. At the time, only the original building, now known as Frisbie Hall, was standing. Dr. Knapp, impressed with the natural beauty of the Schoharie Valley, ultimately became the first director of the school. The railroad station is currently home to Locomotion's Bar and Grill, a popular alumni and student hangout.

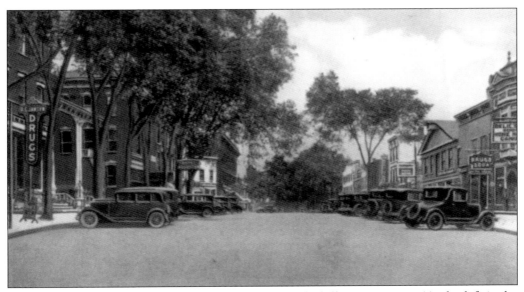

This is an east-facing photograph of downtown Cobleskill's Main Street. To the left is the Hotel Augustan, which is now a furniture store. At the time, prior to campus residence halls, some students would call the hotel home while classes were in session.

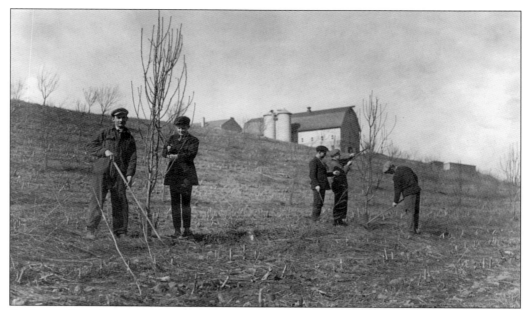

Students plant the original campus orchard in 1918. From the beginning, SUNY Cobleskill students received both classroom and hands-on field instruction in a wide array of agricultural disciplines.

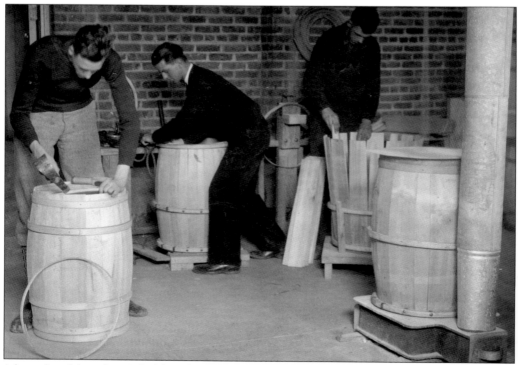

A barrel-making class is held in the basement of Main Building, now Frisbie Hall, in 1918.

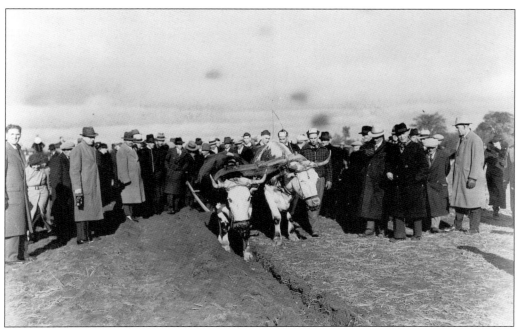

A crowd gathers as oxen are used to break ground for one of the four original buildings in the 1920s. Today, these original structures are referred to collectively as the Old Quad.

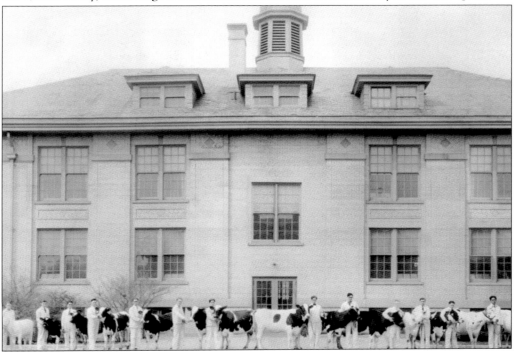

Students participate in the spring dairy show outside of Frisbie Hall in 1919. Frisbie Hall facilitated academic purposes while also accommodating chapel services and student-body meetings.

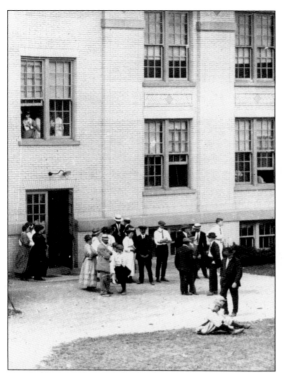

Faculty and students gather outside of Frisbie Hall in the late spring of 1920 after a student baseball game. In the early years, the community would play sports in the crop fields just behind the Old Quad. Today, these areas have been reclaimed for the same purpose.

The following quotation is from the April 1921 issue of the *Voice:* "Party in the Woods: On the night of December 17th, after the victory of the State School over Cooperstown, a little party was held in honor of the Cooperstown fellows (kinda wanted to cheer 'em up). A few games were played. . . . Refreshments, consisting of sandwiches and coffee were served by the refreshments committee. After this, dancing was enjoyed by the frivolous of the company (which was the majority). . . . A fine time was reported by everyone and judging from the time certain members rolled in, it must have been equally enjoyable walking home."

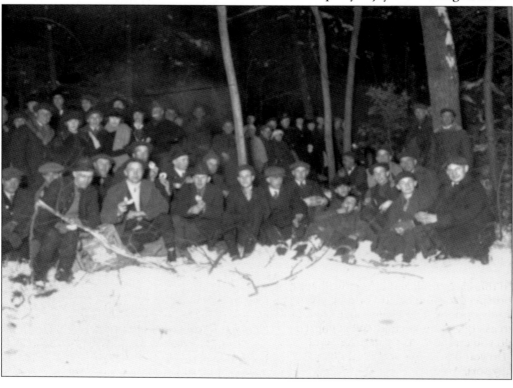

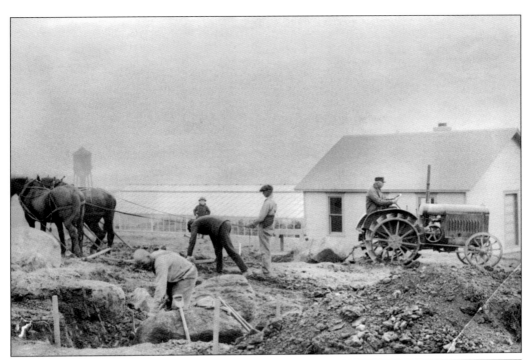

In the spring of 1924, workers began to break ground on the gymnasium building, now known as Old Gym. It took almost 10 years to complete the four original buildings on campus. Old Gym became occupied in September 1926.

In this early application for enrollment, prospective students are offered six study options. The reverse side went on to ask questions such as "What church do you attend?", "Do you sing?", and "Do you have a physical disability of any sort?"

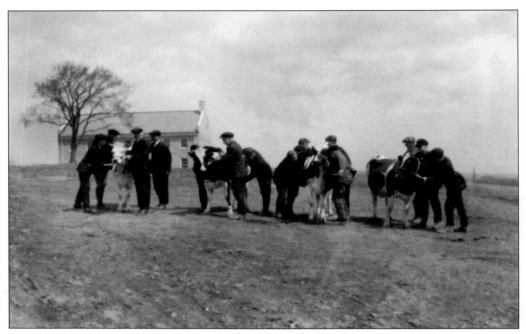

Dairy judging is taking place near the Home Economics building on the Old Quad in the 1920s. Note that Old Gym does not appear in the right portion of the photograph, as its construction did not begin until 1924. It was completed in 1926.

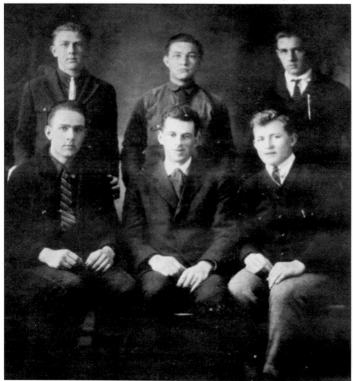

Until the 1930s, Schoharie School of Agriculture would allow students to do a one-year Short Course in agriculture. Students followed many different courses in animal husbandry, dairy science, botany, and chemistry. The six young men posing in 1924 would graduate that year with a poem that reads: "Born in the country / Raised on a farm / A short course at State School / Will do you no harm / The Short Course students of 1924 bid all farewell."

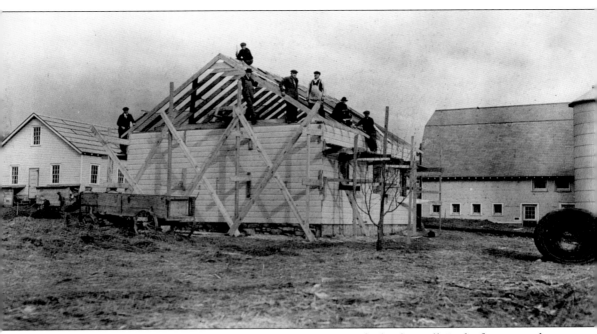

The campus's first dairy barn was located at the current site of Wheeler Hall. In the foreground, two new barns are being constructed by staff and carpentry class students in the early spring of 1926. Here again, students serve as critical farm labor and attain practical experience on campus.

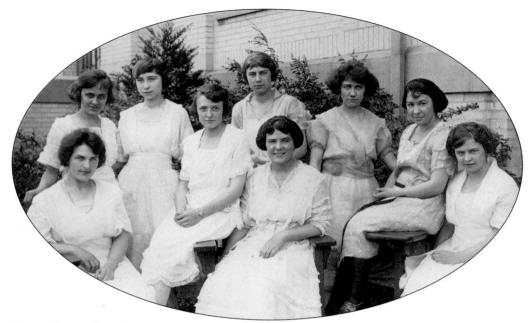

The college's first female students (pictured) graduated in 1922 with degrees in home economics or teacher training. Careers awaiting these graduates included cateress, assistant dietitian, tearoom manager, waitress, cafeteria worker, and dressmaker.

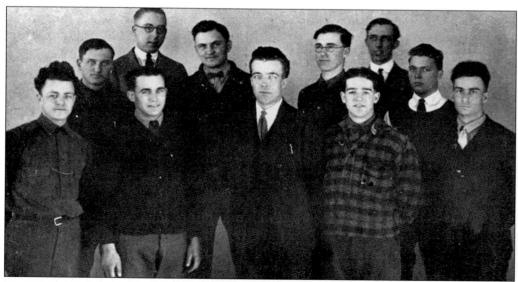

The Feather Club was one of the first clubs founded at the Schoharie State School of Agriculture. This 1924 photograph shows the 11 members of the club, which was a perennial sponsor of Farmers' Week. This event, held each December, showcased animals, produce, eggs, and farm machinery.

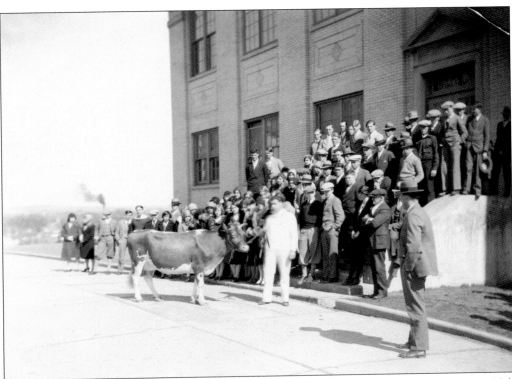

A dairy-cattle show takes place in the Old Quad in front of the Old Gym building in 1924. That year, the college's name was changed from the Schoharie State School of Agriculture to the New York State School of Agriculture.

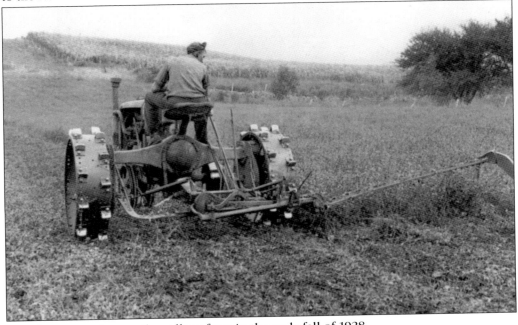

A student mows hay on the college farm in the early fall of 1928.

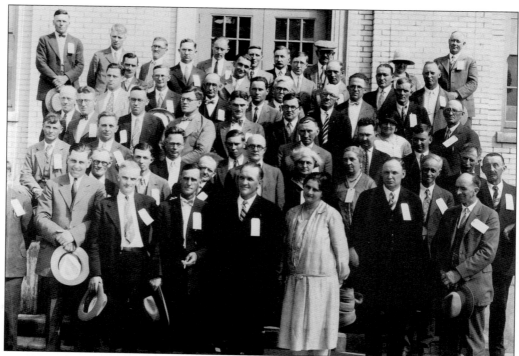

Local leaders in agriculture pose with faculty members at the school in the late 1920s. For decades, the college has invited leaders in various industries to share ideas with the campus community. Among those shown here are Lee Crittenden (first row, third from left), second director at the school; faculty members K. Fox, Emmons Day, and Earl Hodder; and Ray Wheeler (fourth row, fifth from left), who would become director and president of the college in 1947.

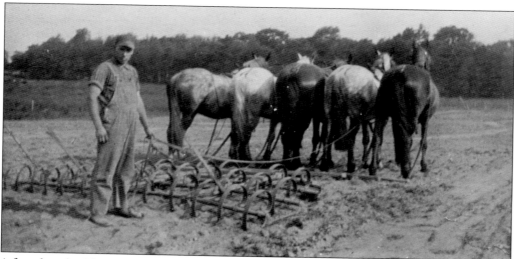

A farmhand with a team of five horses plows one of the campus's fields in 1923. In the school's 100-year history, students have gone on to work in some of the most important entities in the agricultural sector and have excelled because of the college's experiential approach to education.

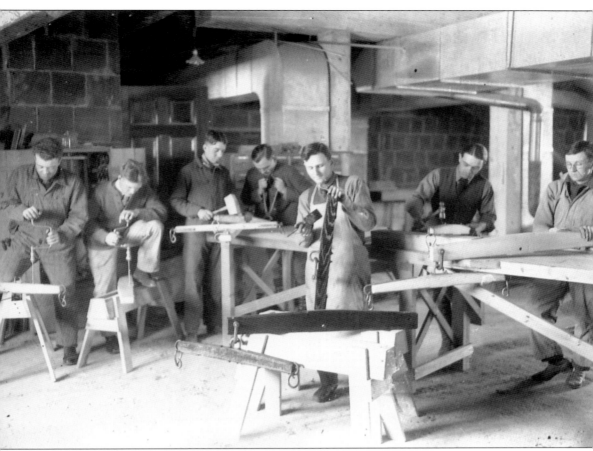

Pictured in the basement of Old Gym on the Old Quad, students make yokes to be used on draft animals for pre-tractor farming activities in 1929.

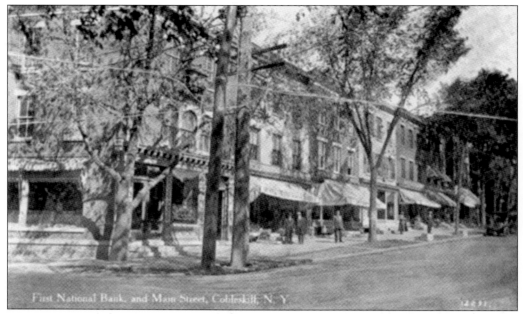

First National Bank was located on the corner of Main and Grand Streets. When Dr. Halsey Knapp arrived in Cobleskill in 1916, he set up a small office on the bank's second floor. In that office, he hired his staff and began preparations for the fall 1916 opening. At the time, downtown consisted of four progressive churches, two banks, a modern library, and many shops and services.

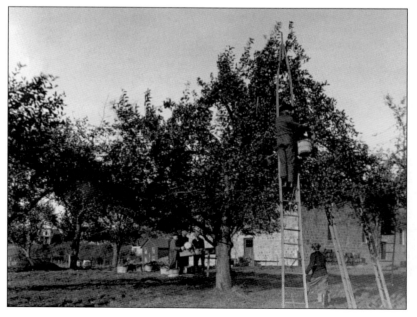

Students pick apples in the fall of 1920 in a small orchard in the village of Cobleskill. The school was an integral part of the community, and it was customary for students to live and work in the village, as is common today as well.

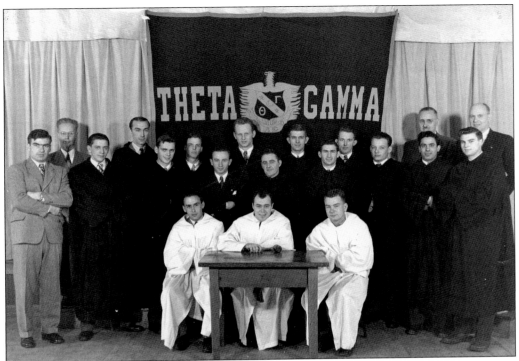

The Epsilon Chapter of Theta Gamma was initiated as one of the campus's first social fraternities in 1923. At SUNY Cobleskill, this fraternity was famous for hosting an annual spring dance and rush banquets at the Hollywood Hotel in Sharon Springs, New York. Shown here is the SUNY Cobleskill chapter in 1940.

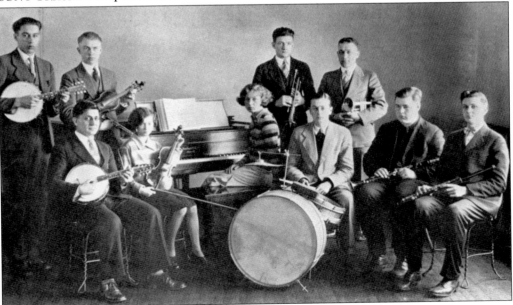

Comprising 10 musicians, the student orchestra, pictured here in 1927, played at various campus events throughout the year.

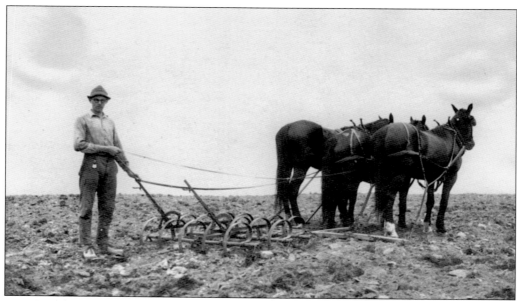

A student plows a campus field in 1923. At the time, the farm consisted of 90 acres adjoining the school. The institution prided itself on producing crops suitable to the region and maintaining a mature orchard of 600 trees of several varieties.

Members of a 1920s agricultural engineering class have gathered for a photograph. The students are showing off just-completed wagon beds, made as part of a farm machinery class.

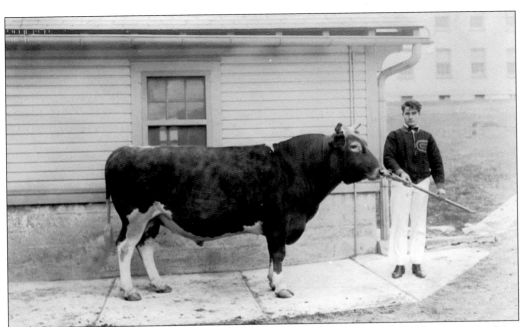

Taken in 1929, this photograph shows an animal husbandry student leading a large dairy bull out of the school's dairy barn. At the time, the school maintained a 30-head dairy herd that included animals from the country's four leading dairy breeds.

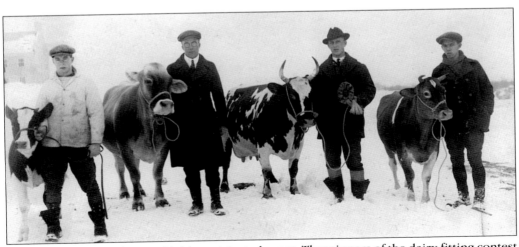

Farmers' Week was always a highly anticipated event. The winners of the dairy-fitting contest pose in December 1924.

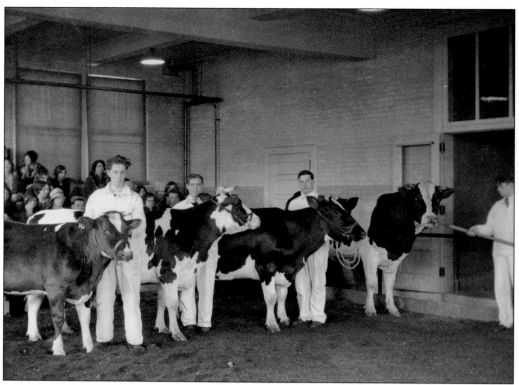

Spectators look on as students participate in a dairy-cattle show in the 1920s.

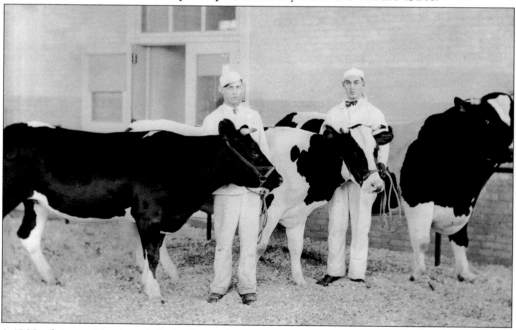

A 1920s dairy-cattle show is being hosted in one of the original barns, located down the hill from the Old Quad.

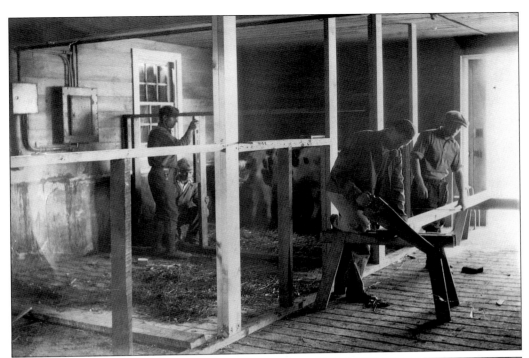

Students and a campus farmhand build calf stalls in 1927. The 1927 graduating class consisted of 17 agricultural students, 10 home economics students, and 33 students in teacher training.

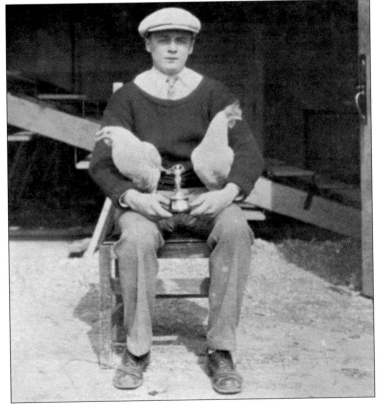

A student poses in 1928 with his two champion hens. Poultry- and egg-judging events were hosted by the Feather Club from the school's beginning until 1959.

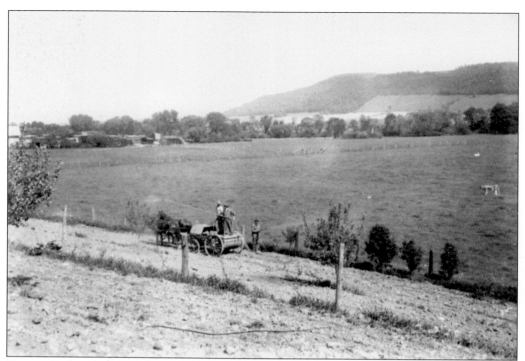

Using a horse and wagon, students spray the fruit trees in the campus's first orchard. The orchard was located in the back of the Old Quad and continued down the hill toward the present sports field location. This photograph was taken in 1921.

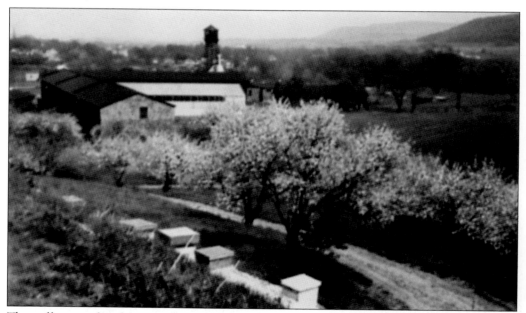

The college orchard is seen here in 1925. The beekeeping class established hives in the orchard for pollination. At the time, the large mill in the background was one of two lumber mills in the village of Cobleskill.

Potato dusting is conducted in 1929. This large tract of land is now the site of the present-day Cobleskill Campus Child Care Center and the nearby Curtis Mott Hall.

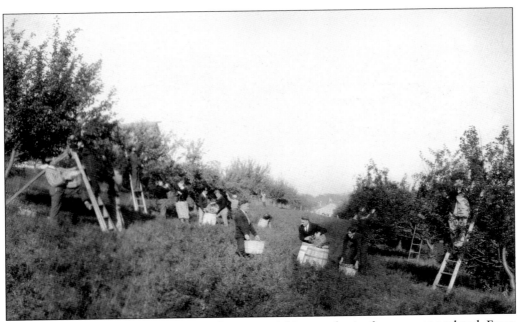

Students and faculty enjoy a late fall afternoon picking apples in the campus orchard. From its beginnings as the Schoharie State School of Agriculture, SUNY Cobleskill has maintained an orchard and continues to do so today.

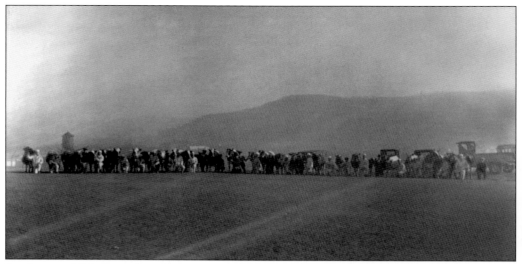

Students exhibit the college's dairy cattle atop the Old Quad in 1921. This photograph was taken prior to the construction of the gymnasium, now known as Old Gym. The foothills of the Catskill Mountains are in the background.

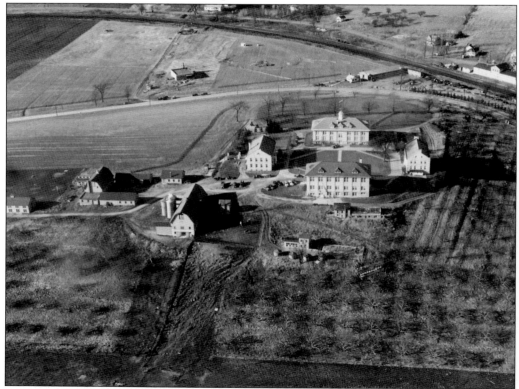

This is the first known aerial photograph of campus, dating to the late 1920s. The four original buildings of the Old Quad are shown, along with cropland and original dairy and poultry barns. At the time, students did not live on campus but, instead, stayed in carriage houses and private residences throughout the village of Cobleskill.

Two

CULTIVATING A COLLEGE
THE TRANSFORMATION YEARS

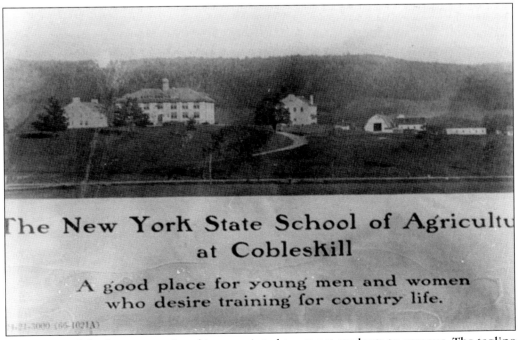

The New York State School of Agricultu[re]
at Cobleskill

A good place for young men and women
who desire training for country life.

This is one of the first promotional items printed to attract students to campus. The tagline reads, "A good place for young men and women who desire training for country life."

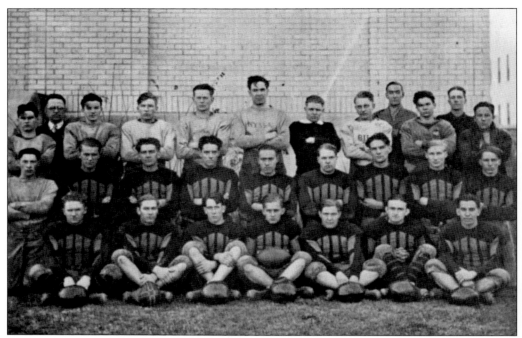

The college's football team was a brief endeavor in the early 1930s, with six uniforms donated by Union College in Schenectady, New York. Instead of buses, the players used Model T Fords to get to and from their games.

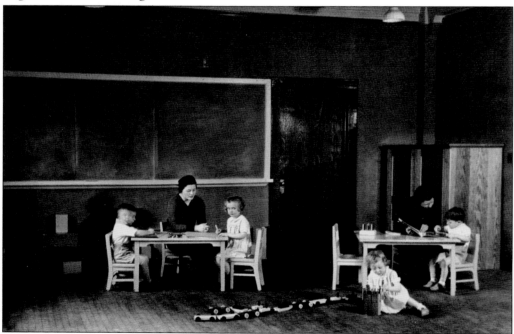

The college's first nursery school is pictured here in 1933. Female students entered the program to learn about child rearing, education, and nutrition. This program has grown tremendously over the decades and now includes psychology and child development.

GLENN J. BOFF
"Boffnagle"—Two Year General Agriculture
Silver Bay High Albany, N. Y.
 Basketball (1, 2), Fitting Contest (1), Manager and Trainer of Cross Country Team (2), Zeta Alpha Phi (2).
"Boff" is the name says this dark boastful lad,
As he sings in deep groans and makes us feel
* sad.*

MALCOLM L. BORST
"Mac"—Teacher Training
Cobleskill High Seward, N. Y.
 Training Class, Basket Ball, Orchestra.
* "What in—tarnation*
* Is wrong with this station?"*
* Thus W8CPA*
* Struggles till the break of day.*

ARTHUR Z. BROOKS
"Arch"—Teacher Training
Chatham Union School Austerlitz, N. Y.
 Annual Speaking Contest Finals, President Dramatic Club, Christmas Play Program, Book Week Program, Training Class Basketball.
* Brooks, a pansy pedantic,*
* Drives his classmates frantic*
* With his learned expositions*
* On ways and means and dispositions.*

ROBERT E. CALHOUN
"Cal"—Animal Husbandry
Troy High Troy, N. Y.
 Student Council (2-1 term), Voice Staff (2), Secretary Senior Class (1st term), Fitting Contest (1,2), Class B. B. (1, 2), Dramatic Club (2), Poultry Fitting Contest (2).
* Red-headed lad with twinkling eye,*
* Bob Calhoun is staid and shy;*
* He's never known to make much noise,—*
* He's a perfect model of model boys.*

MAUDE CARPENTER
"Carpie"—Teacher Training
Granville High Truthville, N. Y.
 Basketball, Secretary Student Council (1 term), Dramatic Club, Vice President Freshman Class, Vice President Senior Class, Senior Play.
* Of all the girls with eyes so sharp*
* There's none can equal Maudie Carp.*
* She slings a wicked basketball,*
* And loves a man who's dark and tall.*

JESSIE CHAMPAGNE
"Jess"—Teacher Training
Galway High Galway, N. Y.
 Girls' Student Council (Sec.), Vice President Dramatic Club, Commencement Speaker.
* Oh, Jessie, sweet, demure and kind,*
* You're just the pal we like to find;—*
* So versatile, so full of pep,*
* You lead the crowd by half a step.*

[17]

In the days of smaller classes, the college's yearbooks took on a unique and humorous twist, as this 1933 page illustrates. Included are nicknames, interests, and whimsical rhymes for each student.

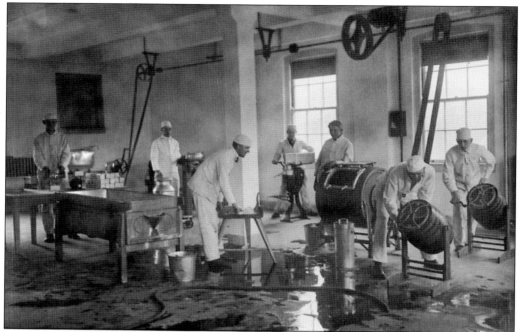

Butter making is seen here in 1934. The dairy-processing facility, in the basement of what is now Alumni Hall, was fitted with a variety of butter-churning equipment. Note here that both hand-crank and pulley systems were used.

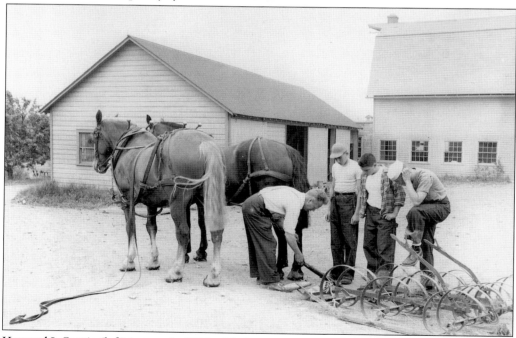

Howard J. Curtis (left) is seen in 1932 with Summer Farm Cadets, hooking up an early piece of cultivation equipment to a team of draft horses. Enrollment increased dramatically during the 1930s, but it gradually declined throughout the 1940s due to World War II.

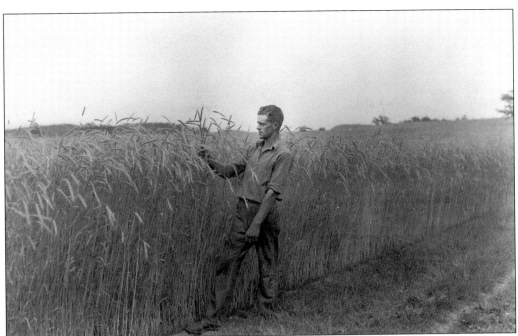

A college farmhand inspects the wheat crop before harvest season in the 1930s. Throughout its 100-year history, the college has employed farmhands, students, Summer Farm Cadets, and the expertise of faculty to oversee the sprawling campus farm.

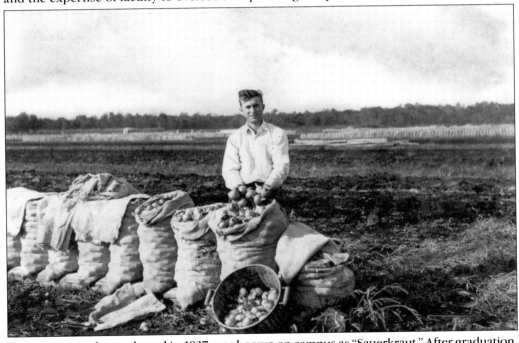

George Weitz, who graduated in 1937, was known on campus as "Sauerkraut." After graduation, he returned to Pine Island in Orange County, New York, famous for its black dirt onions. He was an onion grower there.

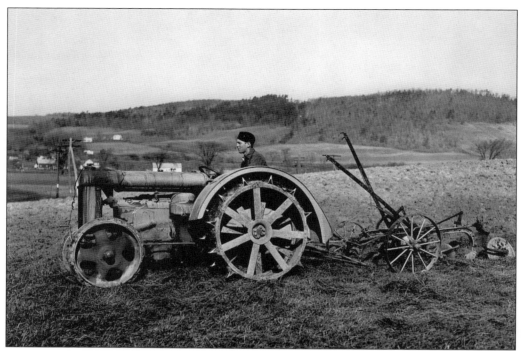

A student plows a fertile field near West Mountain in 1931. Since the early days, the college has integrated "hands-on" learning along with theoretical instruction.

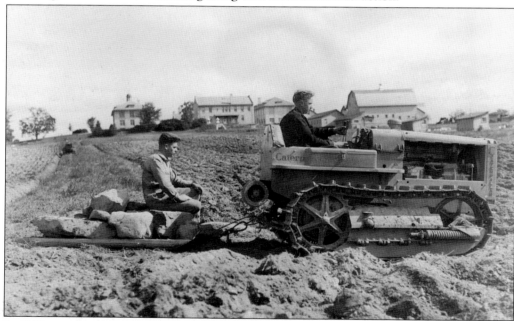

In 1932, two students remove boulders from crop fields near the present-day location of Van Wagenen Library. Agricultural students in the 1930s took a wide variety of classes, including farm problems in society, farm concrete carpentry and machinery, leadership, physical training, and animals and diseases.

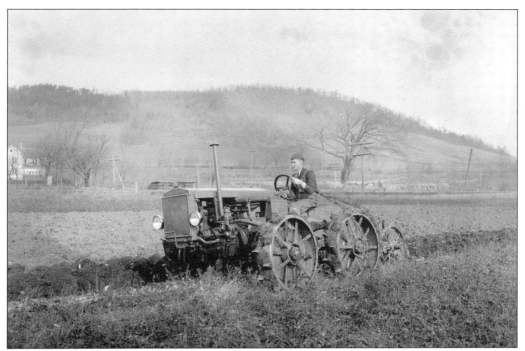

Tractor practice is conducted in the fall of 1931. Freshman Jerold Heath spends an afternoon tilling the soil on the campus farm as part of his agricultural engineering curriculum.

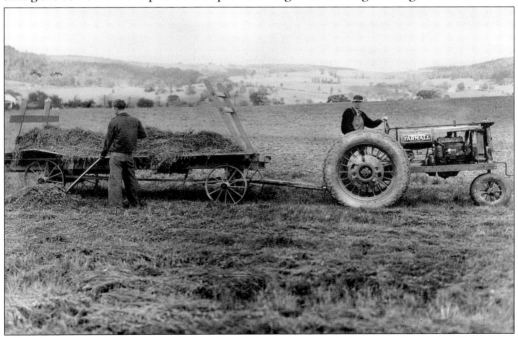

In the fall of 1936, senior Frank Muzikar (left) and junior A. Munroe (right) load hay onto a wagon. Muzikar was assistant director in the school's orchestra and played the trumpet during commencement that year.

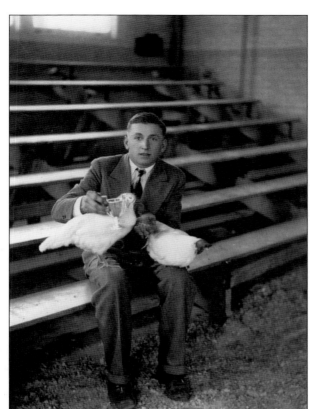

A student poses with his prize-winning hens in the late 1930s. The poultry show was a tradition hosted annually by the Feather Club during Farmers' Week through the early 20th century.

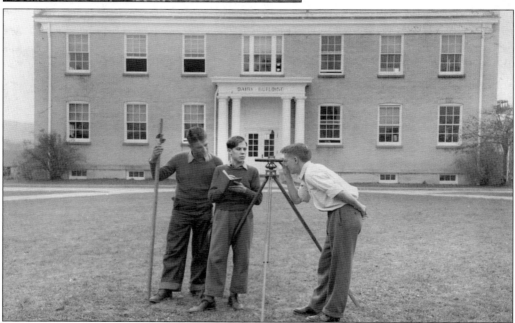

In 1938, students work with land-surveying equipment. Education in land surveying has always been an important part of the curriculum at SUNY Cobleskill.

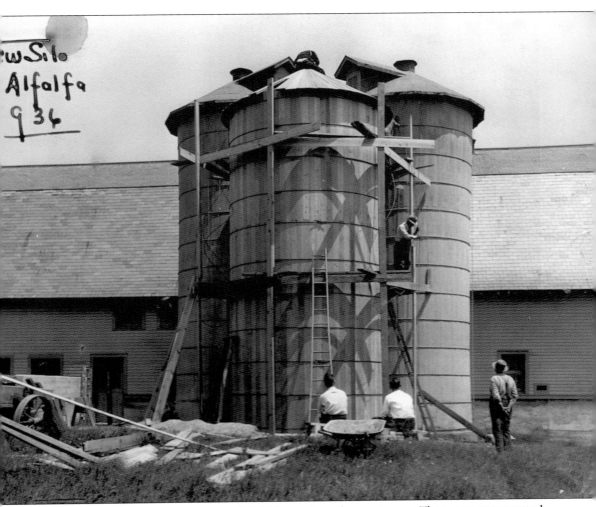

These silos were built in the summer of 1936 for grain and crop storage. They were constructed beside the original dairy and horse barns, originally located directly behind modern-day Alumni Hall.

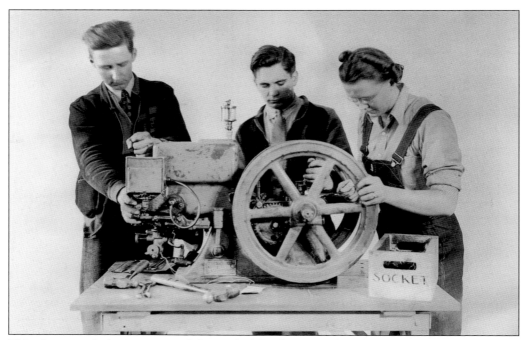

This photograph depicts a typical day in the life of an agricultural engineering student. These three students in 1938 work side-by-side, exploring the components of farm machinery. Note the presence of a female student.

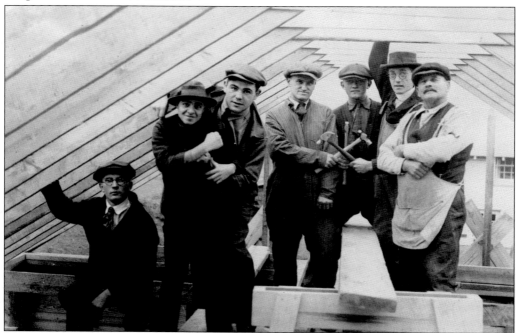

Carpentry students help to build a barn on the campus farm in the 1930s. Found in the 1932–1933 college catalog is an advanced carpentry course, offering students exposure to rafter layout, designing roof trusses, setting windows and doors, and material calculation.

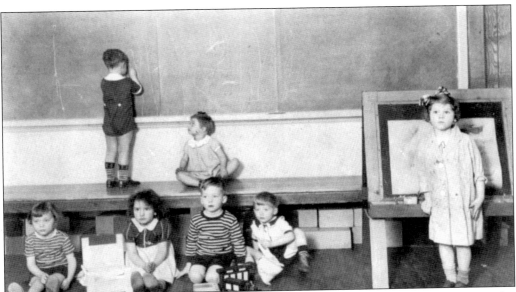

Early childhood education is seen at the college in the 1930s. These children are at the college's day-care center. Since its development more than 80 years ago, this program has been nationally recognized. Today, it is known for training students in preparation for employment as case managers and lead teachers in both public and private child-care facilities.

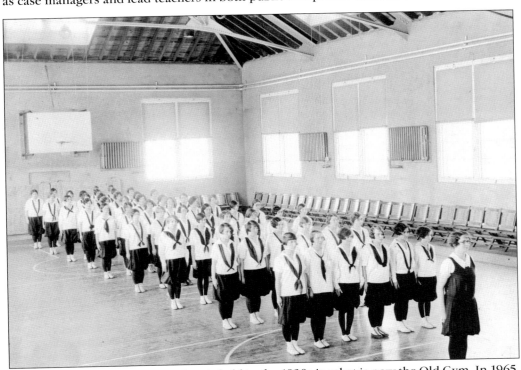

A women's physical education class is held in the 1930s in what is now the Old Gym. In 1965, Bouck Hall was completed, providing a new gymnasium. The second floor of the Old Gym was then converted to the Grosvenor Art Gallery, named in honor of John Grosvenor.

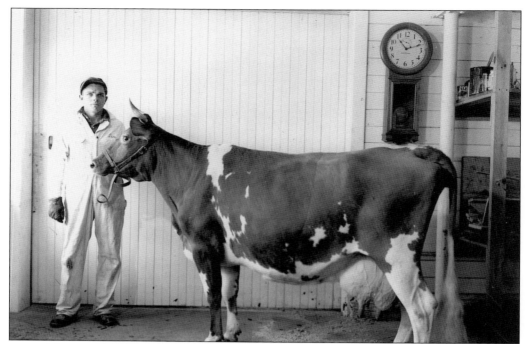

One of the college's dairy herdsmen poses with a prize Guernsey cow in 1932. The cattle barn had room for 40 head and was equipped for practical work by students.

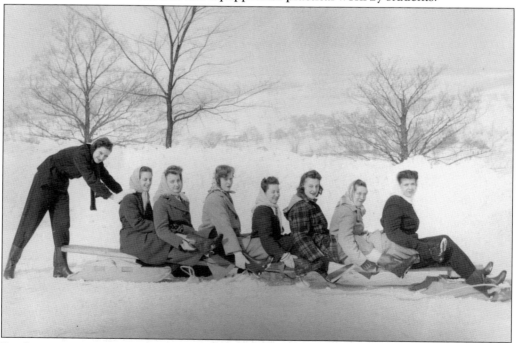

Students enjoy a snowy day on the Old Quad in the 1930s. Sledding is a long-standing campus tradition. Whether on a sled or a dining hall tray, students take time for a joy ride down the hills.

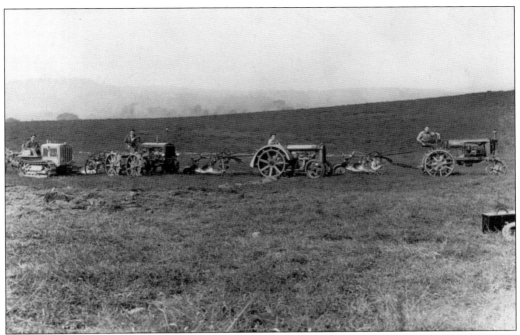

Farm machinery class students are seen in 1931. West Mountain, which would later become the site of the Frederic R. Bennett Recreation Center and Ski Lodge, can be seen in the background.

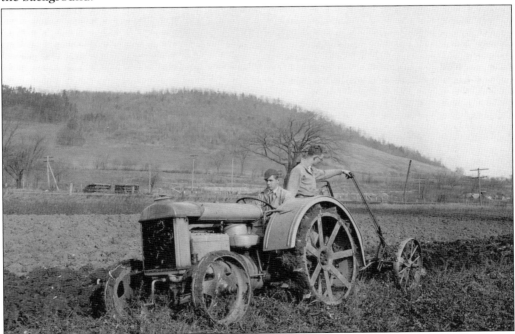

Students learn safety and machinery techniques during tractor practice in fields located near the present-day Cobleskill Campus Child Care Center. At the time, the school farm consisted of more than 90 acres surrounding and adjoining the campus.

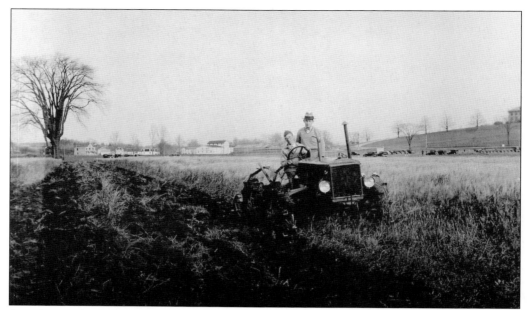

A student and an instructor spend the afternoon plowing a field in the late fall of 1931. Visible in the background is the area where the current alumni-owned Kelley Farm and Garden store now stands. A portion of Frisbie Hall, or the Main Building, can be seen at right. At the time of this photograph, the student body numbered 150.

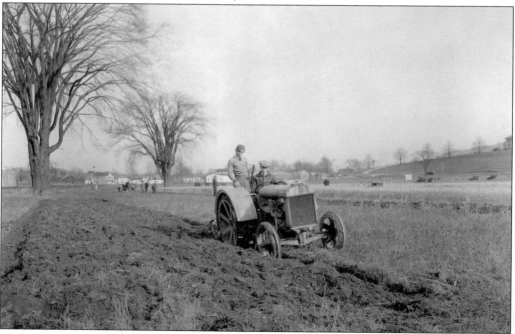

In 1934, two students plow the lower fields during tractor practice. The France Milling Company can be seen behind the young men. In the early 1900s, the milling company was one of the area's largest employers. Today, SUNY Cobleskill is the largest employer in Schoharie County.

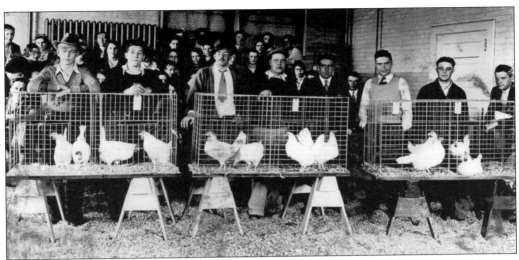

A poultry-judging class is held in 1934. Poultry science remained one of the most popular areas of study at the college until 1959, when the campus poultry barn burned to the ground.

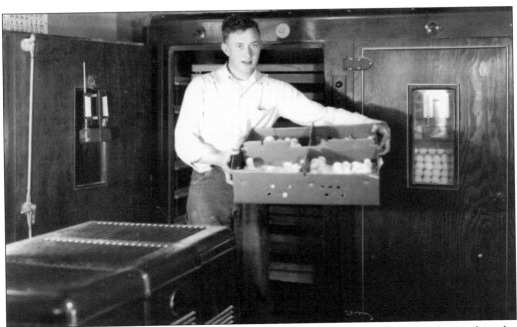

A student shows just-hatched chicks from the college's incubator facilities, housed in the basement of Main Building (Frisbie Hall) in the 1930s.

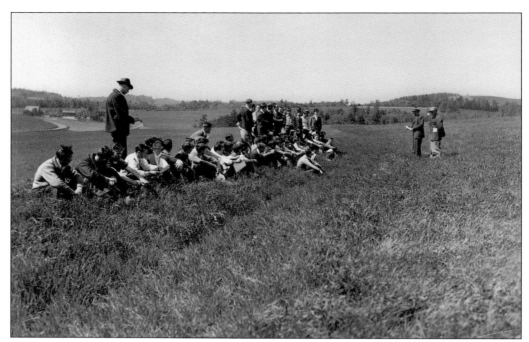

Students and faculty enjoy an outside tutorial on soil science in the early fall of 1938. Today, students commonly work beyond the walls of their classroom, utilizing the campus grounds for hands-on learning.

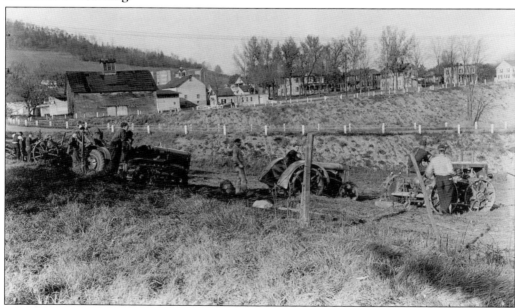

Tractor practice is seen here in the fall of 1933. The Schoharie State School of Agriculture was originally created for young men who were not interested in completing high school—it was, in fact, an early example of what is now known as vocational school. It was an experiment, and one that the state was willing to invest in, to the point that tuition was free and potential students only had to show completion of eighth grade and be 16 years old.

Youth from all over Upstate New York were invited to participate in the livestock exhibition event seen here in the 1930s. Later, this tradition became the annual High School Day, which is still held in the early fall each year. Youth from New York and surrounding Northeast states participate in this day of agricultural education and faculty demonstrations.

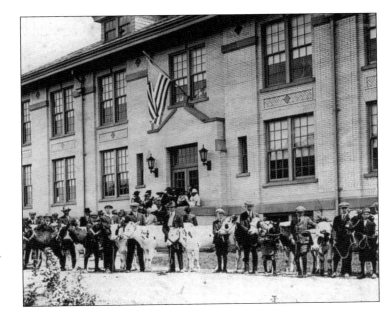

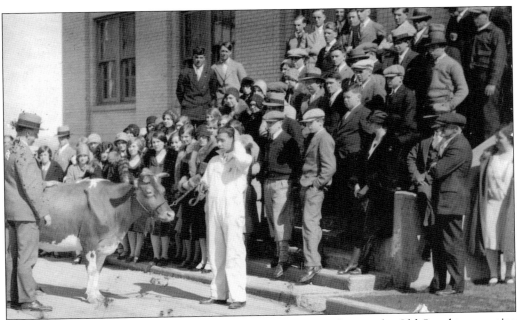

This is a dairy-judging class in 1937. Faculty and students gather on the Old Quad to appraise one of the college's many dairy heifers.

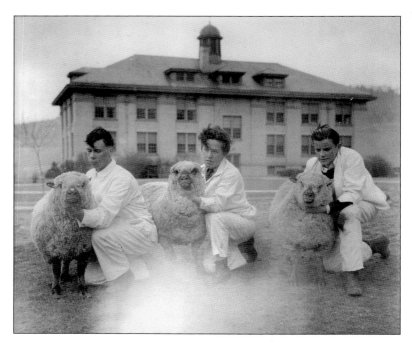

These are the 1934 sheep-fitting contest winners. Throughout the 20th century, this show was traditionally hosted on the lawn of the Old Quad. Frisbie Hall is seen in the background.

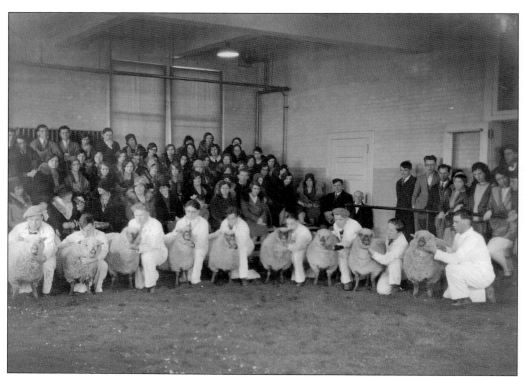

A campus sheep show is held in 1934. Early animal husbandry students not only were required to do course work, but they also participated in raising the college's livestock. Livestock exhibitions on campus were common in the early 20th century.

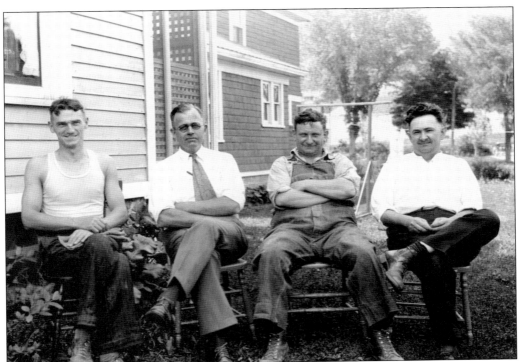

Enjoying a much-deserved break in 1934 are, from left to right, Ray Wheeler (president, 1947–1961), Howard J. Curtis (agricultural mechanics professor and namesake of Curtis Mott Hall), George D. Gregory (poultry science teacher), and Lee Huey (poultry science teacher).

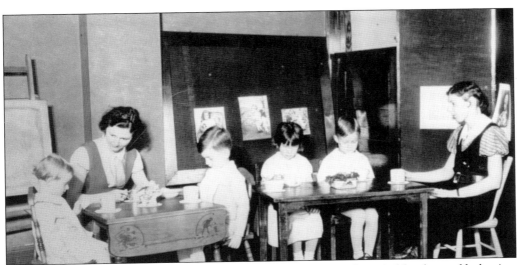

College students care for children while practicing techniques for suitable play and behavior. Today, Holmes Hall is the central academic location for early childhood program students who complete a 230-hour practicum in their second year and a 450-hour internship for the program's baccalaureate degree. More recently, SUNY Cobleskill has partnered with several graduate schools with master's programs in early childhood education.

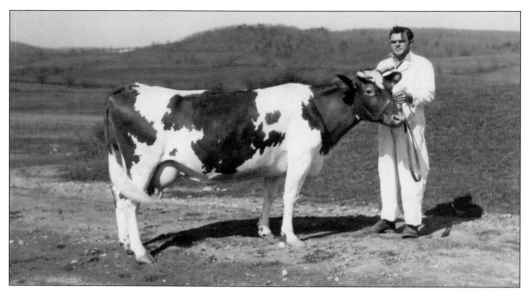

A student poses with one of the campus's prized Ayrshire dairy cows in 1932.

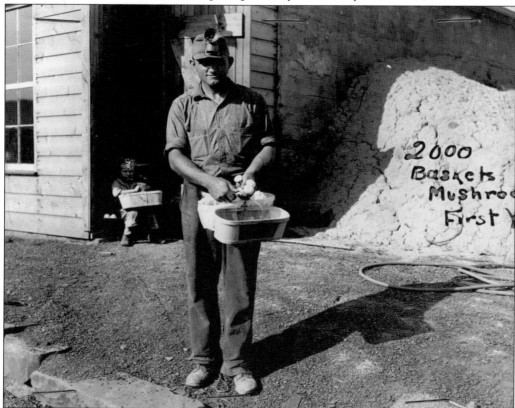

Jansen Dederick of Saugerties, New York, graduated in 1934. He is seen here in 1936, working on his mushroom farm in Upstate New York. Today, more than 10,000 graduates continue to reside and work in New York State.

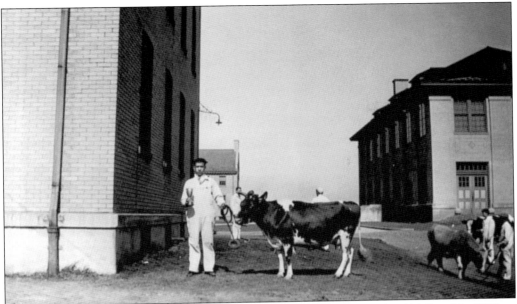

A student stands with his first-prize heifer at a dairy exhibition on the Old Quad in 1931.

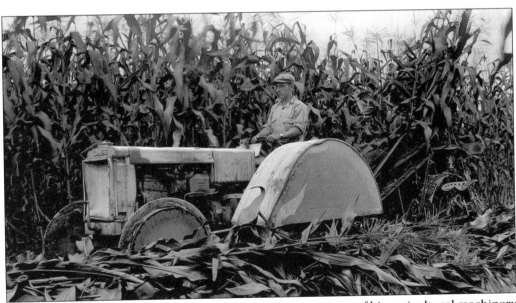

A student devotes his afternoon to harvesting field corn as part of his agricultural machinery course in the fall of 1934. Students today spend countless hours working the college's 900-plus-acre farm, which serves as a living laboratory.

A campus draft horse is photographed in the early 1930s. The setting is present-day Alumni Hall in the Old Quad. In the formative years of the campus, large draft horses were used with farm equipment to tend to cropland.

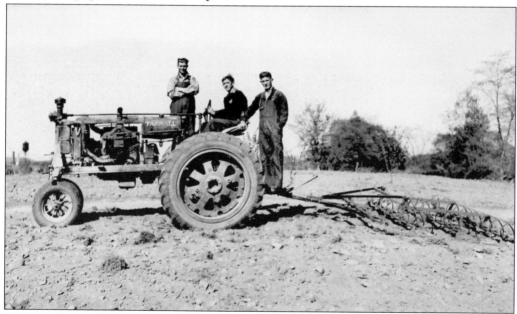

In the 1930s, two students and a farmhand till the soil near the current sports fields. The school's motto, "Real life, real learning," exemplifies its commitment for students to learn by doing.

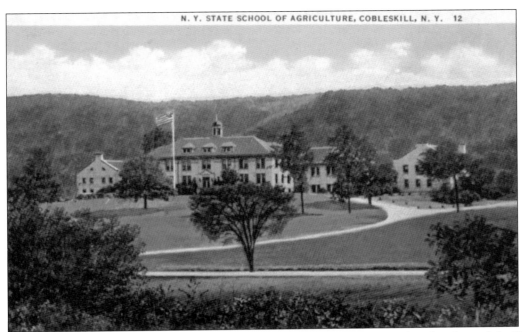

This is an early postcard from the 1930s. Hand-colored postcards were produced in the early half of the 20th century and depicted rural landscapes and noteworthy sites across America.

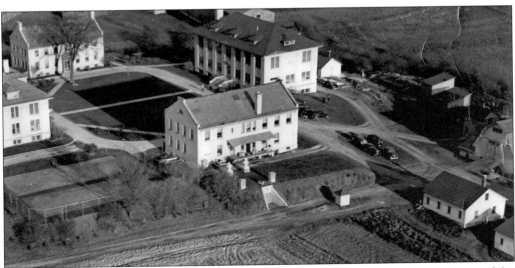

This is a 1940 aerial photograph of the Old Quad on SUNY Cobleskill's campus. Some of the college's original cropland and barns can be seen in the lower portion of the photograph.

53

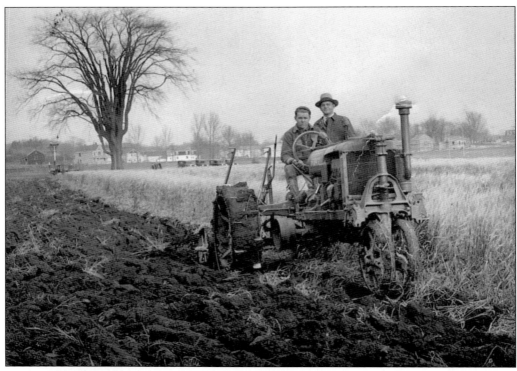

Howard J. Curtis was a longtime faculty member in the farm mechanics program. Here, Curtis works in 1940 with a student, tilling the soil in early spring along what is now State Route 7. Visible in the background are village homes.

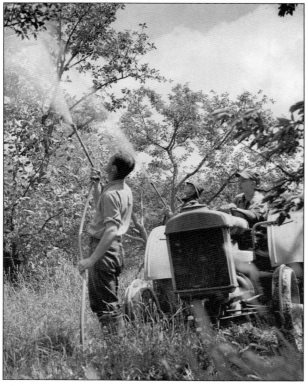

Students work alongside faculty and professional staff, spraying fruit trees in the college's orchard in 1940.

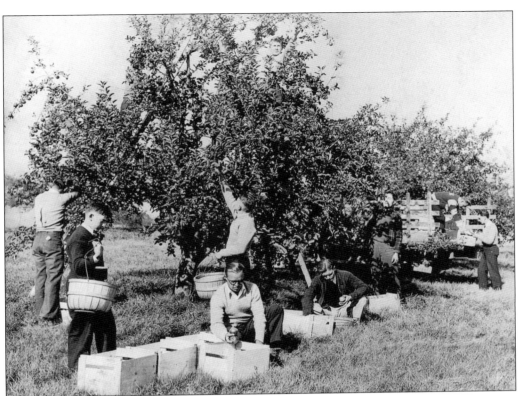

Howard J. Curtis and his students from farm mechanics and fruit science classes enjoy an afternoon of apple picking at the campus orchard in the fall of 1942.

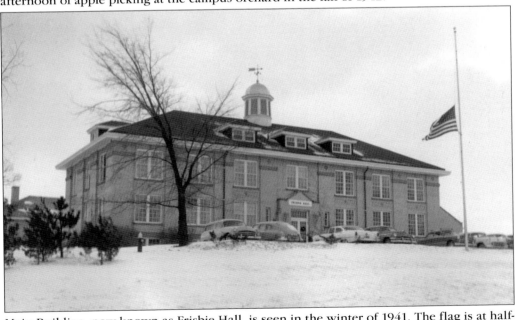

Main Building, now known as Frisbie Hall, is seen in the winter of 1941. The flag is at half-mast to commemorate the December 7 attack on Pearl Harbor.

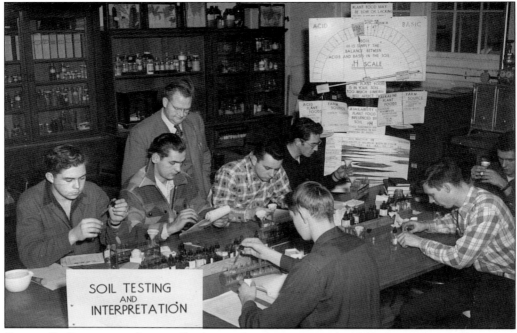

George D. Gregory teaches a soil science chemistry course in 1941. Gregory was a longtime professor who specialized in chemistry and English studies.

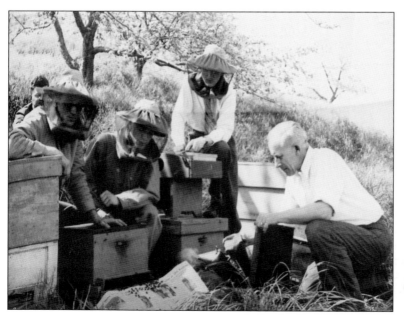

Earl H. Hodder (right) was instrumental in the early years of gardening and orchard sciences at SUNY Cobleskill. These students are receiving beekeeping instruction in the orchard in 1948.

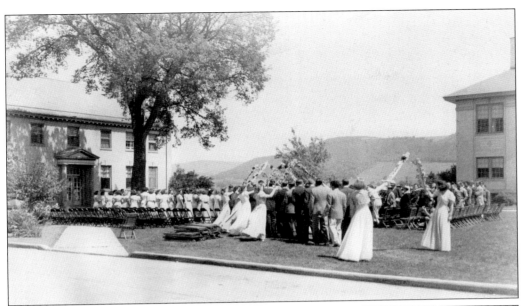

In the early years, commencement was held on the Old Quad lawn. Seen here is a ceremony in the 1940s. Note all the young ladies in white gowns. Today, graduation is held down the hill, on Crittenden Athletic Fields. In 2014, more than 500 students graduated with associate or bachelor's degrees.

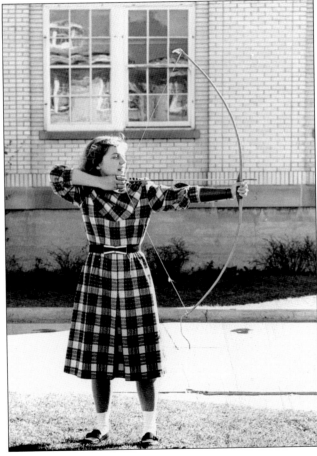

Archery has long been both a recreational and club sport on the college campus. Here, a young student practices on the lawn of Old Quad in the fall of 1949. Archery Club now practices every week and hosts events on campus.

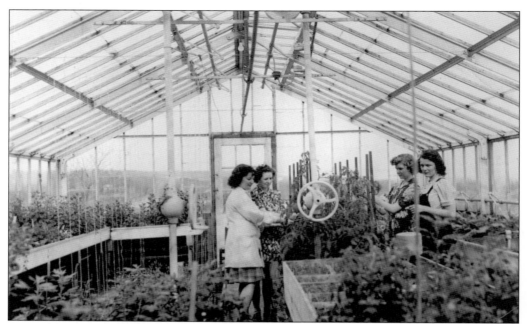

In 1946, these young ladies work in the college's original greenhouse, located just behind Alumni Hall. Today, the school boasts over 20,000 square feet of greenhouse space.

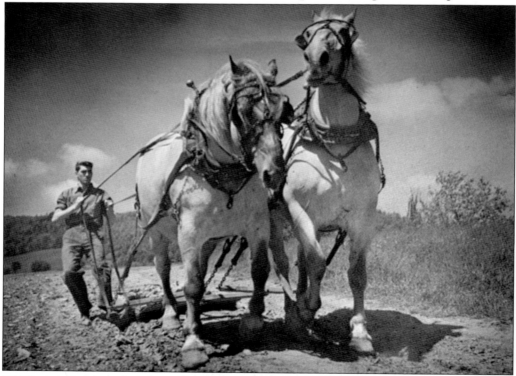

Ed Kinne, who attended the college from 1941 to 1943, drives a team of Belgian horses to prepare cropland for planting near what is now Curtis Mott Hall.

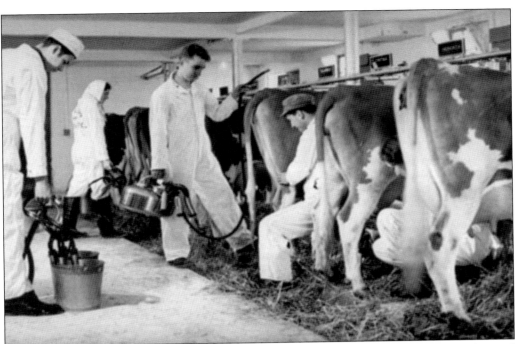

Students milk cattle in the college's original dairy barn in the 1940s. The barn was located on the current site of Wheeler Hall.

These students, both nursery education majors, make toys for young children in the 1940s. The first campus nursery school opened in 1933, providing practicum experience for students of the new child-care program.

Local school students visit the campus in the late 1940s. Throughout its existence, the college has opened its doors to young students from the community and throughout the Northeast to tour farm facilities and participate in a variety of educational events.

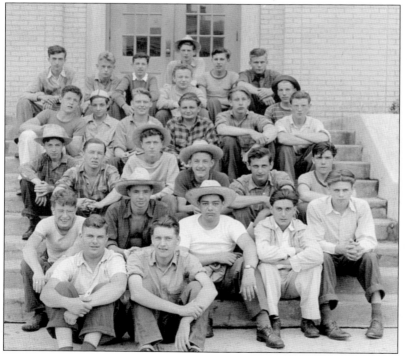

These Summer Farm Cadets pose in 1942. The Summer Farm Cadet program has been operating in New York State for over 100 years. Its aim is to expose New York City high school students to the rigors and joys of farming and rural life.

Summer Farm Cadets saddle a horse with the assistance of one of the college's farmhands as they prepare to work cropland in 1943. They are working in front of one of the campus's original barns, located near the Old Quad.

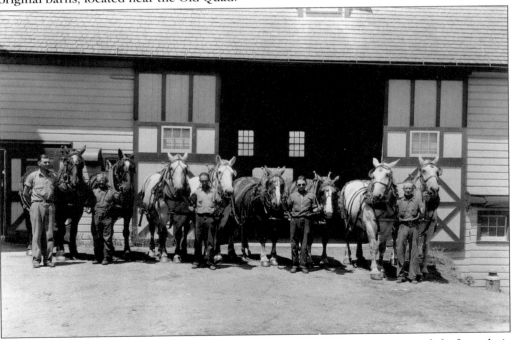

Draft horses at one of the college's original barns pause for a photograph before their workday begins.

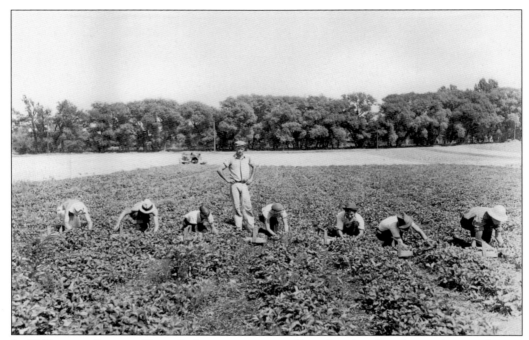

In 1942, seven Summer Farm Cadets are supervised by a farmhand as they pick green beans. For many summers, cadets from schools in New York City would arrive at SUNY Cobleskill to work and learn at the college farm.

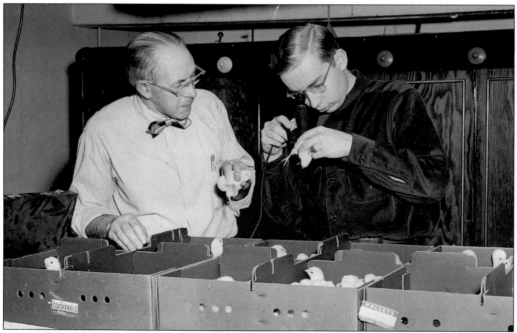

Prof. Merle Rodgers (left) and a student inspect newly hatched chickens in 1949. Specifically, they are "sexing" the chicks to determine their gender. The school's poultry program would continue another 10 years until the 1959 poultry barn fire.

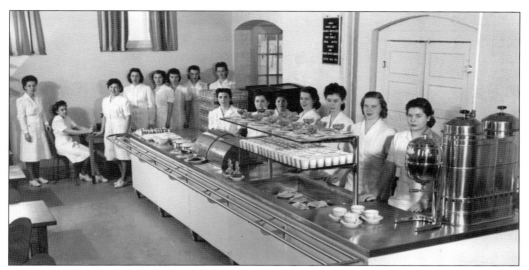

This 1948 photograph shows the college's cafeteria and its staff in Main Building, known as Frisbie Hall today. More than 200 students were served each day at this location. Food services were later established around campus in high-traffic areas. Today, the Cobleskill Auxiliary Service administers campus dining, including at Champlin Hall and Prentice Hall, along with a restaurant on Main Street.

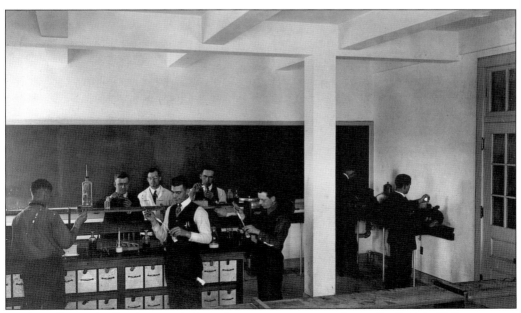

Students learn the fundamentals in a chemistry course conducted in Frisbie Hall.

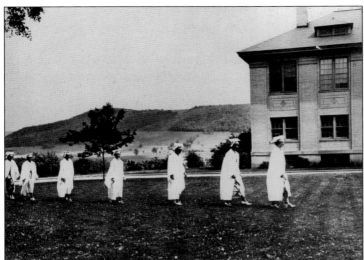

Students prepare for the ceremony on commencement day in the early 1940s. In the college's early years, each graduate participated in commencement ceremonies by delivering a five-minute statement. The first ceremony graduated six students and was held in the second-floor auditorium of what is now Frisbie Hall.

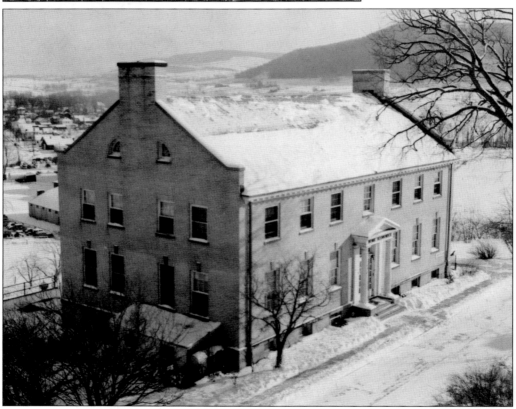

Construction on the Home Economics building, one of the four original campus structures, was completed in 1920. It originally housed classes in home economics and nursery education. A 1932–1933 college catalog highlights the Home Economics facilities: "Home conditions have been duplicated as far as possible. The large and spacious living room offers to all the girls the ample opportunity to put into practice simple rules of hospitality and entertainment in the home."

In the mid-1940s, two female students take a tractor application course. With many men away during World War II, the female population on campus soared, and women took over many farm duties.

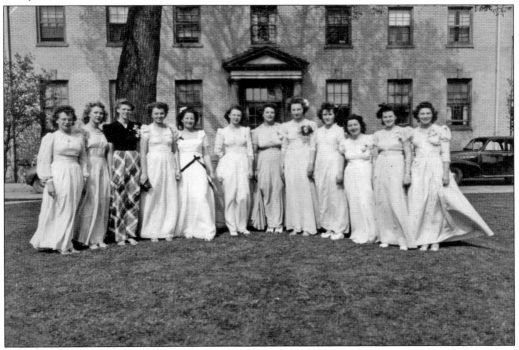

Posing in front of the Home Economics building, these female students are ready for what is believed to be the 1944 commencement.

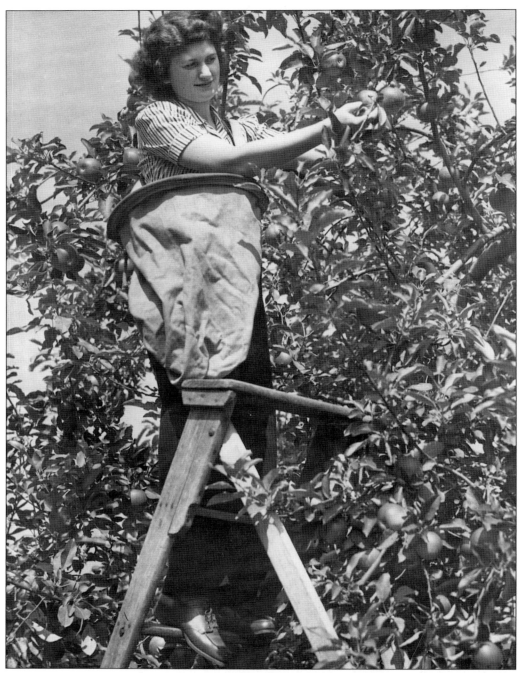

A student picks apples in the school's orchard in the 1940s. At the height of World War II, in 1944, the college yearbook noted: "With war time limitations and restrictions all about us, the collection of the materials and subsequent publication of this yearbook has not been an easy task, and we hope you will bear with us in our short comings, remembering that upper-most in our hearts and minds, and yours also we believe, has been the sincere prayer that our loved ones are safe and will soon return to us again."

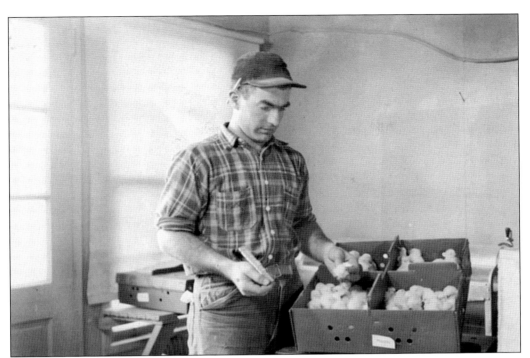
This student takes inventory of chicks in the school's poultry barn in 1949.

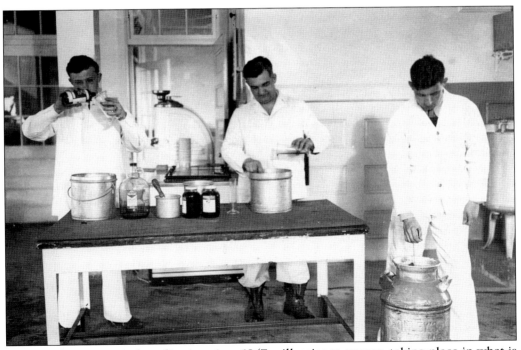
Students learn practical applications in a 1947 milk science course, taking place in what is now the basement of Alumni Hall.

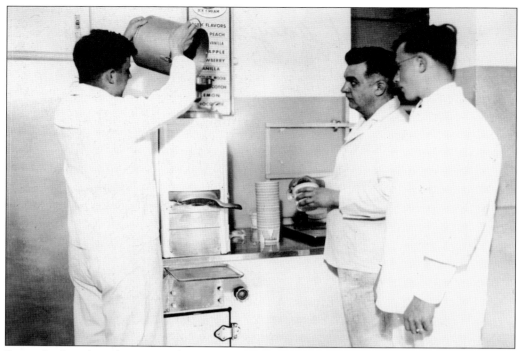

Supervised students learn to make ice cream. In the last decade, SUNY Cobleskill has dedicated more resources to its dairy facilities. With a state-of-the-art dairy barn and milking parlor, the college currently milks 200 cows, three times a day.

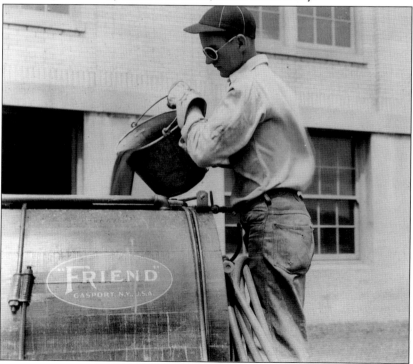

In 1940, a student mixes chemicals for use on campus orchard trees that were located behind Old Gym.

A basketball game takes place in the spring of 1943 in Old Gym. Its first team established in 1917, basketball is the oldest sport that SUNY Cobleskill maintains today. In the early days, SUNY Cobleskill would play local high schools and colleges.

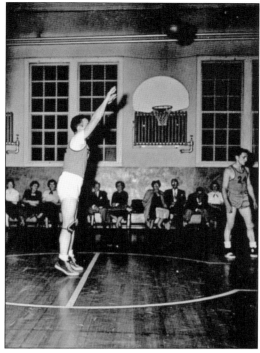

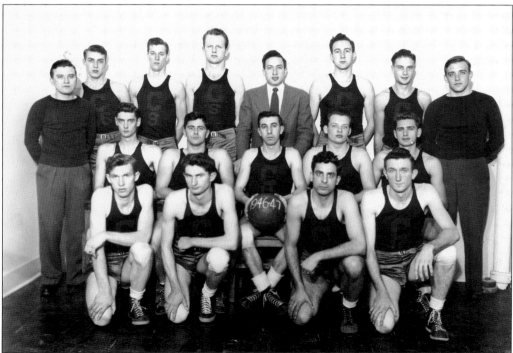

This is the 1946 New York State Institute of Agriculture and Home Economics basketball team. Basketball had just been revived at the college after a brief hiatus during World War II. Games were played against Albany, Canton, Morrisville, Delhi, Farmingdale, and Hartwick.

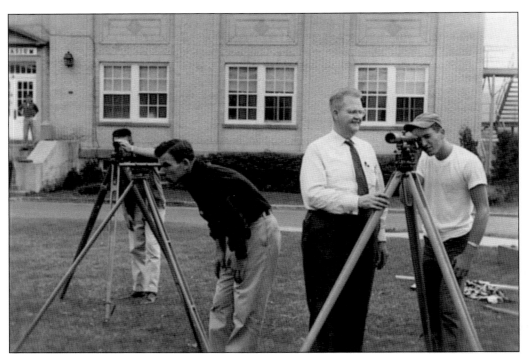

Faculty member Norman J. Curtis (second from right) instructs students in land surveying on the lawn of the Old Quad in 1949. Dr. Curtis received his baccalaureate degree from Kansas State and his master's and PhD from Rutgers.

SUNY Cobleskill administrators are seen in 1949 on the future construction site of Ryder Hall, which served as the first on-campus student housing. Today, Ryder Hall accommodates faculty offices.

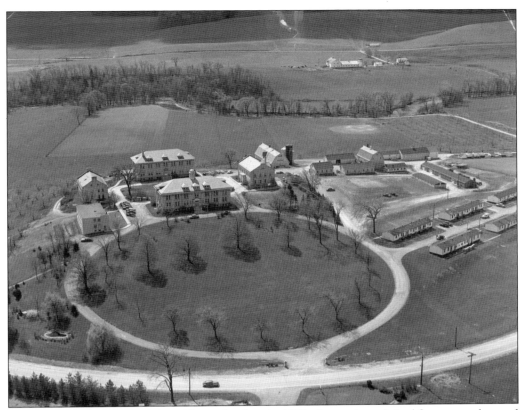

This aerial photograph of the Old Quad, taken in 1951, shows the original farm complex and recent additions of student housing for veterans. These track houses, made from old Army barracks, served as living quarters for married veterans after World War II and were located in the vicinity of present-day Wieting Hall. At the very top of the photograph, the Coby farm, which borders the Cobleskill Creek, can be seen. This farm was acquired by the Cobleskill Auxiliary Services in 2014 and will serve as crop and grazing acreage for the college.

This is a 1950s postcard of the campus. These cards would have been passed out to prospective students and their families upon visiting campus in the mid-20th century.

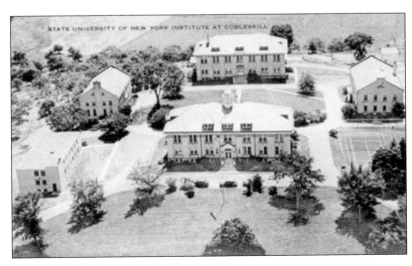

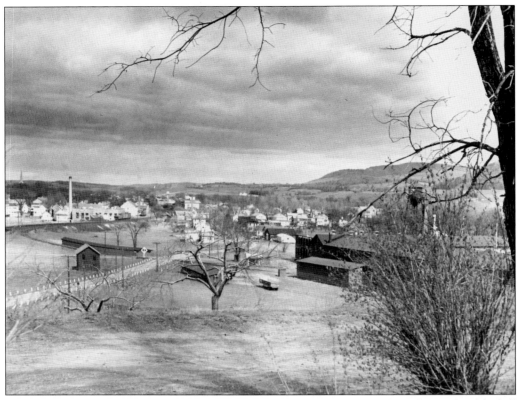

This is a view from the back of the Old Quad, looking down toward the village of Cobleskill and the Schoharie Valley. The village of Cobleskill was settled in 1752 and was named after a mill owner, Jacob Kobel, who built his mill along Cobleskill Creek. The Cobleskill Historic District is listed in the National Register of Historic Places.

Commencement was traditionally held on the lawn of the Old Quad in early May. In 1950, approximately 125 students graduated from the college.

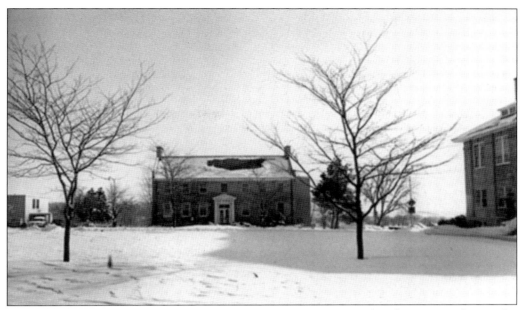

The Home Economics building, pictured in the 1950s, was completed in 1920 to house the home economics program. Young ladies participated in classes such as sewing and handwork, laundering, housewifery, English literature, and millinery. In recent years, the building housed the wildlife management program until the opening of the Center for Agriculture and Natural Resources. Currently, the building is slated for a complete renovation.

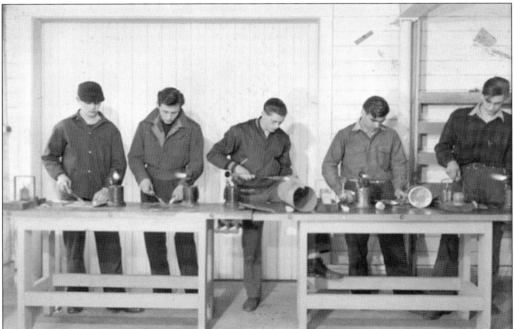

As farming evolved from the horse-and-buggy era to the use of farm machinery, the college kept pace by developing mechanics courses. Students in this class in the 1950s learn engine repair.

Frederick "Joe" Tober ('55, left) and his classmate Jimmy Walsh (right) pose for a photograph in January 1954. A few months after this photograph, Walsh left his studies for the military. Throughout SUNY Cobleskill's history, students have tried to balance their education and military service. Today, SUNY Cobleskill has a Student Veterans Association. Its goal is to provide student veterans with the necessary guidance and services to ensure their personal and academic success.

Students make holiday wreaths and decorations in 1950, possibly for an upcoming social event.

The 1957 cheerleading team had the important job of keeping spirits high as the Aggies played on. The 1957 *Voice* yearbook describes the squad: " 'Fight Team Fight' echoes across the gym as our peppy cheerleaders lead the students in the cheers at our games. The cheerleaders are chosen at the end of their junior year and immediately start practicing for the year ahead. We will all agree that Captain Diane Dodge, Evelyn Ellis, Shirley Boyce, Dina Davey and Mary Ellen Keenen (pictured here) have added vim and vigor at our home games and have supported the team excellently this year. Miss Phyllis Smith is advisor to the cheerleading squad."

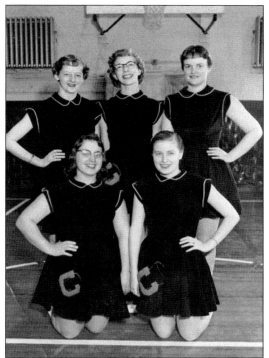

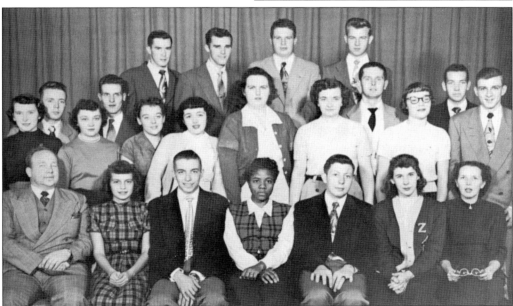

The first Orange Key Society members take a moment from their ambassador duties to pose for a photograph. "A group of elected students who have been tapped into the organization in recognition of their many contributions to school affairs. The Society was started in May of 1952. Its main purpose is to act as hosts to visitors during such events as Open House Day, and to better inter-collegiate feelings during sport events," read the 1952 *Voice* yearbook. This organization was active until 2013.

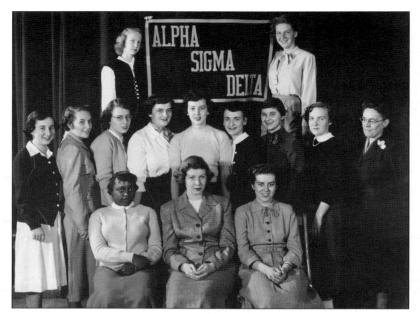

The Cobleskill College chapter of the Alpha Sigma Delta social sorority poses in 1951. Helen E. Brock (seated, left) was vice president of Alpha Sigma, secretary for the Women's Student Government Association, and was one of only two African American students to graduate in 1951.

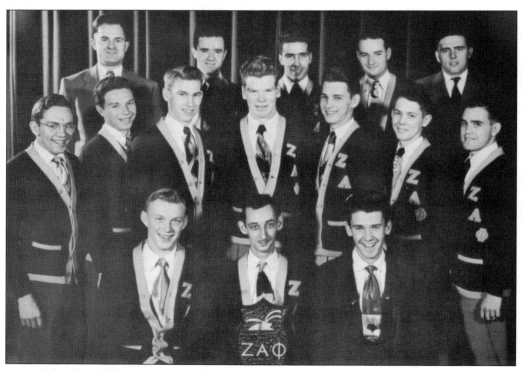

Zeta Alpha Phi (ZAP) was one of the strongest and most active fraternal organizations in the history of the college. ZAP alumni continue to have reunions and positively influence the campus with their support of the Zeta Alpha Phi Fraternity–Carl Whitebread Memorial Scholarship. The former fraternity house at 436 West Main Street is now The Gables Bed & Breakfast Inn.

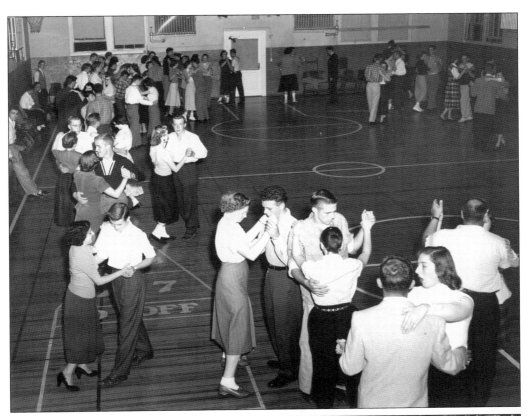

The Old Gym doubled as space for physical education and as host for events, such as this spring dance sponsored by Theta Gamma Epsilon Chapter in 1958.

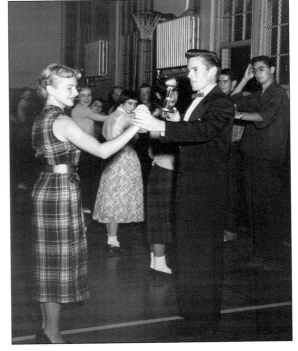

Students look to follow instruction, possibly for a square dance, at this social event in 1955. Square Dance Club was a popular campus group in the 1950s. It had its own four-person band.

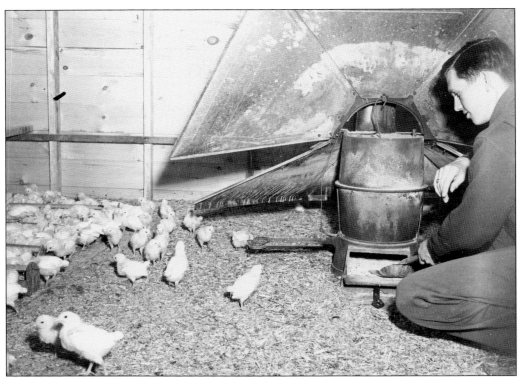

In 1952, a poultry science student works in the poultry barn, raising young chickens.

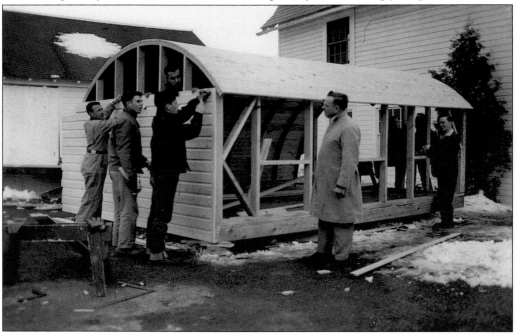

Students work together in the winter of 1952 to build a poultry house. Carpentry students and animal husbandry students are collaborating on this project.

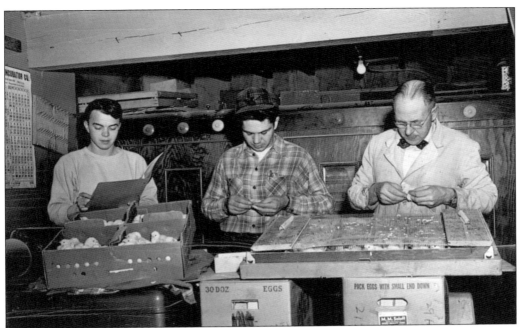

Under the guidance of their professor, students in this 1950s poultry science class learn the correct technique for "sexing" baby chicks.

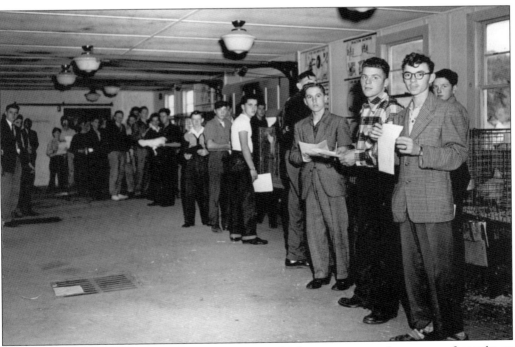

This is a 1950s class in poultry science, which was a popular area of study at SUNY Cobleskill.

Students practice operating dairy science equipment in the mid-1950s to produce ice cream, using milk from the campus herd.

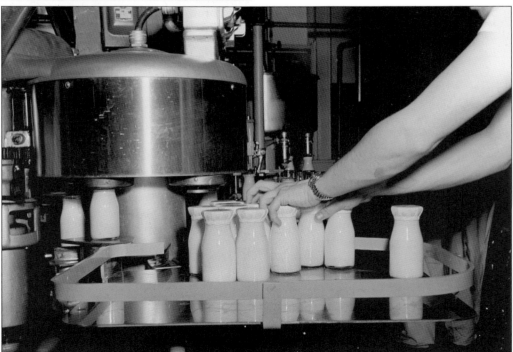

The college produced and processed its own milk since its beginnings as the Schoharie State School of Agriculture. Over time, the college produced a wide array of products, including bottled milk, cheese, cottage cheese, yogurt, and ice cream.

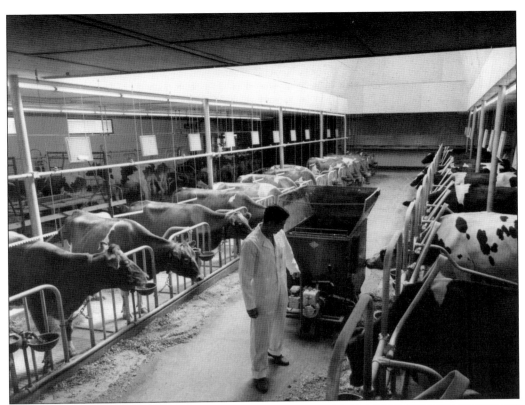

This is the campus's second dairy barn, which was located near the present-day Center of Agriculture and Natural Resources. Today's dairy barn, located up the hill on the north side of campus, continues to offer students on-campus employment and practical application.

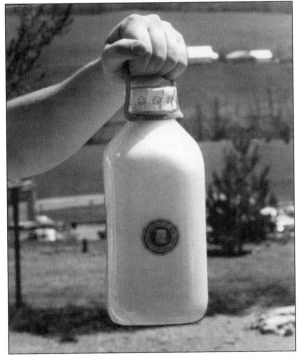

This is a sample of milk bottled on campus in the 1950s. SUNY Cobleskill has always prided itself on its farm-to-table approach to food service. Though dairy-processing operations on campus ceased in the 1970s, SUNY Cobleskill initiated the process of constructing a new dairy-processing facility in 2015.

Students work together in the 1950s on a collaborative assignment. Today, students are afforded the opportunity to work with professors on special projects and individualized research.

The library has always been essential to student success in program studies and related research. In 1973, the Van Wagenen Library opened its doors, offering students a comprehensive set of resources in one location. Today's students complement their classroom experience with 62,000 books, 3,800 audiovisual materials, 28,000 e-books, 210 journal subscriptions, and more than 30 full-text research databases. Jared Van Wagenen, the library's namesake, was an agricultural pioneer who hailed from nearby Lawyersville, New York.

SUNY Cobleskill has always recognized the importance of business education, incorporating this coursework into its earliest programs. By 1959, the college began offering major options in business, secretarial science, and accounting. Business administration and information technology remain an instrumental part of general education for all students, with several related majors available to students today.

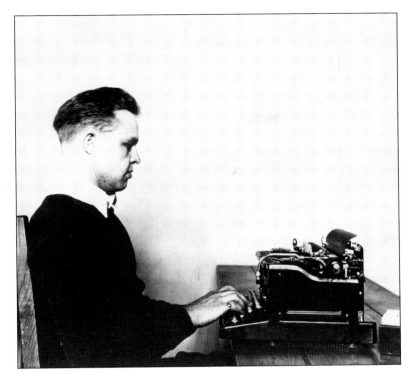

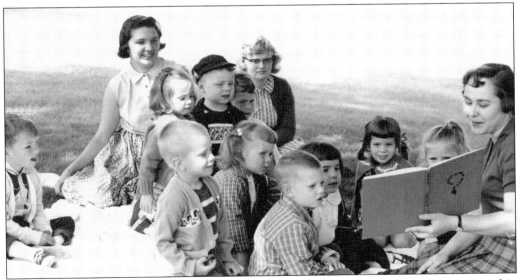

An early childhood education program is shown here in 1952. Students are instrumental in running the Effie Bennett-Powe Child Development Center in Holmes Hall, named for Bennett-Powe, a professor who was influential in the growth of the early childhood curriculum. The center offers high-quality preschool for children ages three to five.

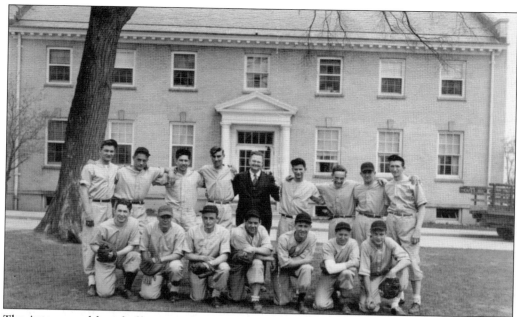

The intramural baseball team of the New York State Institute of Agriculture and Home Economics at Cobleskill is seen here in the 1950s. It played teams from regional schools, including RPI, Utica, and Oneonta. In the early 1970s, SUNY Cobleskill's nickname transitioned from the Aggies to the Fighting Tigers.

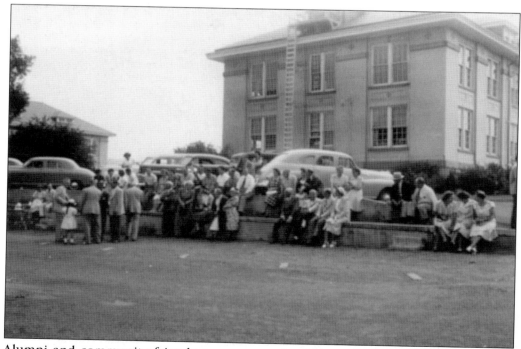

Alumni and community friends convene on the Old Quad during alumni weekend in 1953.

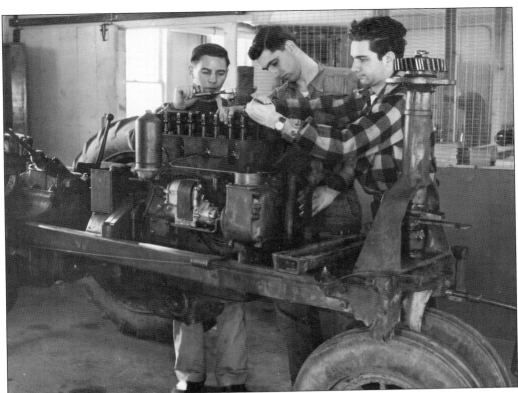

Agricultural engineering students work on farm equipment for use on the campus property. Since the college opened its doors in 1916, students have provided critical support for the day-to-day farm operations. Today, agricultural engineering students continue to work with program faculty to maintain state-of-the-art agricultural equipment.

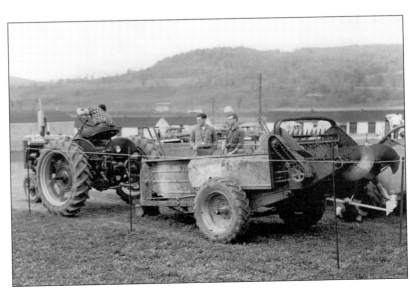

Students look over the essential farm equipment during a tractor practice in 1950.

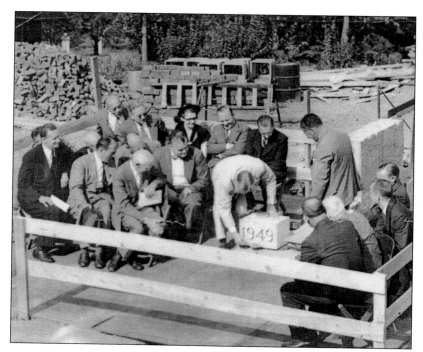

The cornerstone of Ryder Hall is being laid in 1949. This residence hall for females was completed in May 1950. The building was named after Frank H. Ryder, president of the college's Board of Visitors, now known as the College Council.

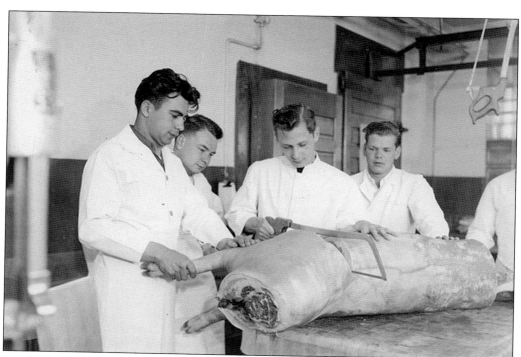

Butchery is a skill that the college has been instrumental in preserving. One of only a few schools to have a USDA meat-processing facility on campus, SUNY Cobleskill allows students to explore the science of meat processing. This photograph dates to the early 1950s.

In 1950, students practice sawing techniques while preparing lumber for light campus construction.

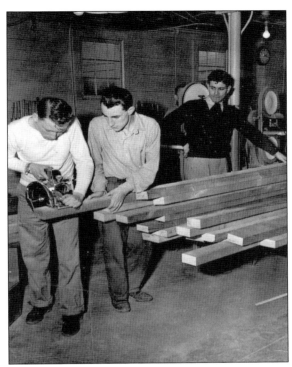

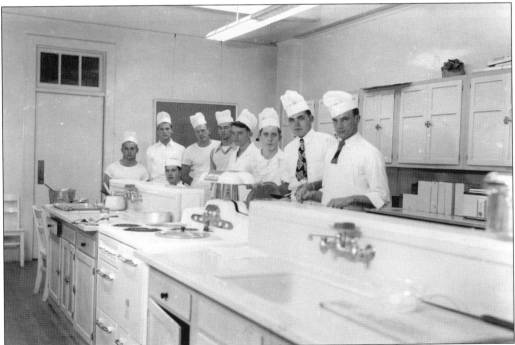

Shown here is one of the campus kitchens. Students were able to secure campus employment working in dining halls. Today, Cobleskill Auxiliary Services employs hundreds of students in dining halls. Such employment helps to supplement tuition costs.

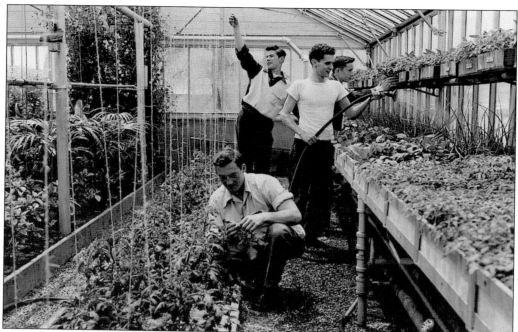

In 1959, four students tend to the greenhouses. Those enrolled in plant sciences were often in charge of greenhouse layout and plant production. These students are tending to tomatoes growing upward on the ropes hanging from the ceiling.

Students pay close attention to Dr. Norman J. Curtis in a crop-production laboratory course in the 1950s. This lab room had housed a fruit and vegetable canning plant in the later years of World War II.

Students make Christmas decorations for a campus party in 1952.

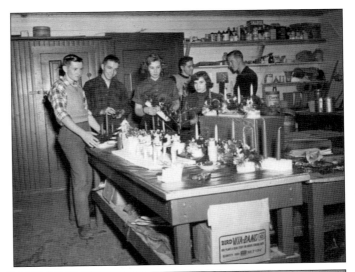

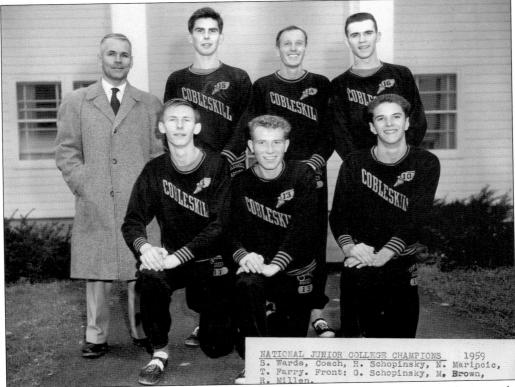

NATIONAL JUNIOR COLLEGE CHAMPIONS 1959
S. Warde, Coach, R. Schopinsky, N. Marincic,
T. Farry. Front: G. Schopinsky, M, Brown,
R. Millen.

The 1959 Cross Country National Junior College champions team poses for a photograph. Shown here are, from left to right, (first row) Gerald Schopinsky ('61), Matthew Brown Jr. ('61), and Robert Millen ('62); (second row) coach Stephen "Pop" Warde, Richard Schopinsky ('60), Norman Marincic ('60), and Thomas Farry ('61). In appreciation for the lasting impact SUNY Cobleskill had on them, Richard and Gerald Schopinsky later established two scholarship funds with the college, providing multiple students with financial assistance each year. Scholarships are essential to the academic success of SUNY Cobleskill students.

Students pose with beef and dairy cattle in a 1959 showmanship competition, held behind what is now known as Alumni Hall.

This is a dairy-judging class in 1953, with the college's original barns visible in the background. The barn area would be relocated to accommodate the ground breaking of Wheeler Hall in 1963.

The great fire of 1959 consumed and destroyed the campus's original poultry barn. Neither the barn nor the poultry science program were resurrected, and the campus's Feather Club ceased to exist. Today, poultry are housed in the college's hog barn, and poultry science classes are offered through the animal science program.

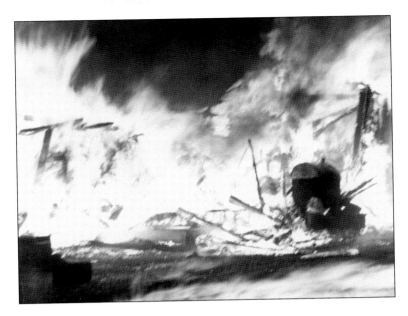

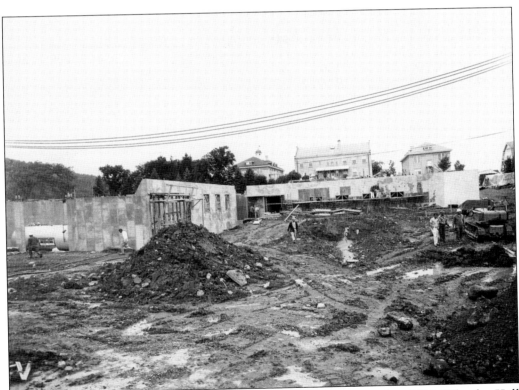

Ground breaking for Wheeler Hall took place in 1963. Renovated in 2011, Wheeler Hall now houses the natural science, histotechnology, and paramedic programs, complete with state-of-the-art laboratories and lecture facilities. The building is named for Ray L. Wheeler, the college's fifth president (1947–1961).

This is a view of the president's house in 1967. Equipment is being used to dig the pond situated along State Route 7, next to the new Center for Agriculture and Natural Resources.

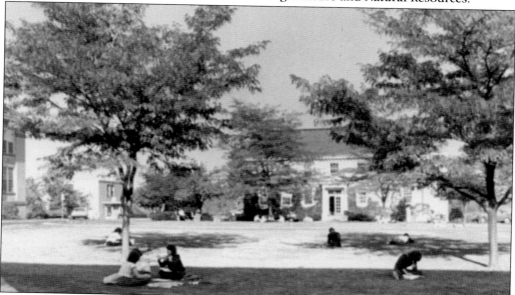

Students enjoy a warm early fall afternoon on the lawn of the Old Quad, as they have for 100 years.

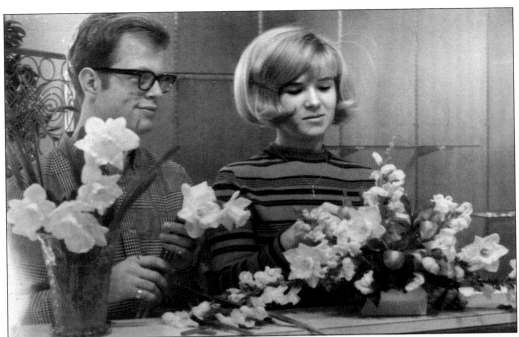

Students learn the art of arranging flowers in a floral-design course in the early 1960s. Plant science students have long been afforded not only the experience of growing and tending to plants, but also the opportunity to collaborate creatively with floral arrangement and organizing plants for sale. Historically, students have been able to exhibit their designs at various flower shows.

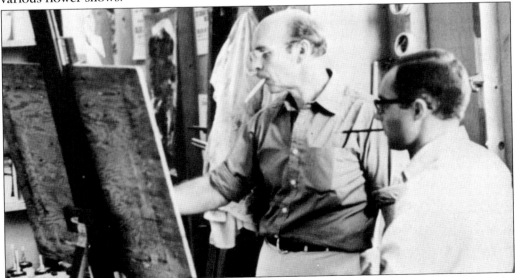

When Bouck Hall opened in 1965, the second floor of the Old Gym was converted to the Grosvenor Art Gallery, named in honor of John Grosvenor, seen here at work. He was instrumental in the humanities arena and brought amateur acting to a new level with his formation of the Little Theater Group. Today, the gym floor lines are still visible, and the space houses studio art classes and exhibitions.

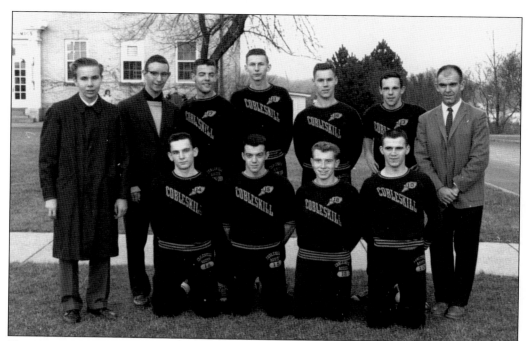

The SUNY Cobleskill men's cross-country team poses in 1961. The college remains competitive in cross-country racing, as it has been for most of its history. The coach, Frederic Bennett (far right), was a leader in SUNY Cobleskill athletics for many years and is the namesake of the Frederic R. Bennett Recreation Area and Ski Lodge.

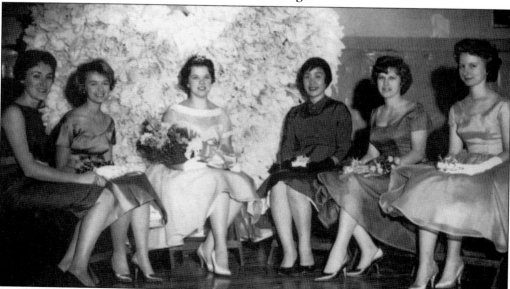

Shown here are, from left to right, Jean Pesce, Maryann Bukovich, queen Laurel Bailey, Yachiyo Shimizu, Linda Skeele, and Michele Horton. On January 4, 1962, Laurel "Lou" Bailey was crowned the first annual Campus queen. Bailey was selected from this group of six students by the 1962 senior class. The results of the election were kept secret until the moment of the crowning.

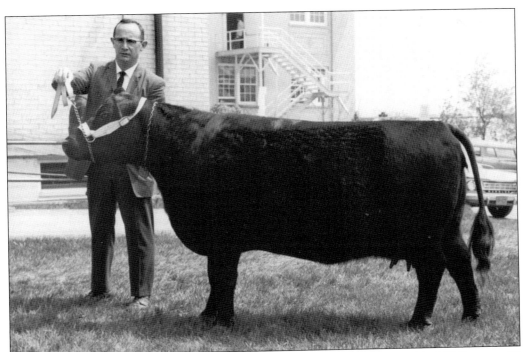

Dr. Robert McGuire served as a professor of animal science at SUNY Cobleskill for over 30 years, retiring in the 1990s. He was a longtime advisor of the Livestock and Dairy Cattle Clubs and coached the men's soccer team from 1962 to 1967. He is pictured here with one of the college's Angus cattle in the mid-1960s on the Old Quad.

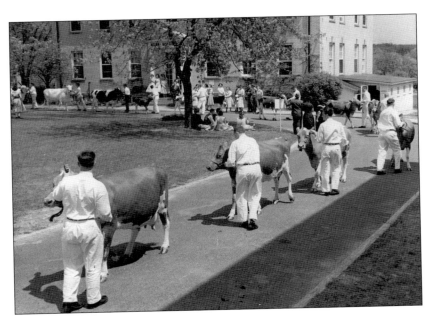

Students and cattle look their best for a parade around the Old Quad in 1963.

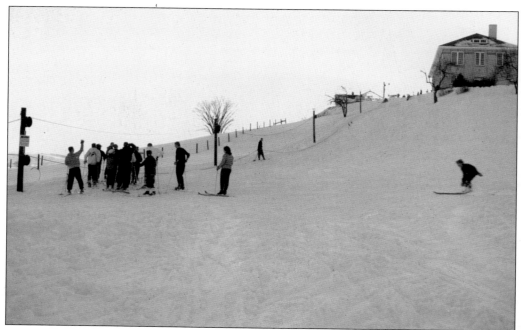

Students ski the slopes behind Old Quad in 1961. Downhill and cross-country skiing were popular leisure activities for SUNY Cobleskill students throughout the 20th century. Note the tow rope, powered by a large diesel engine, used to pull skiers back up the hill.

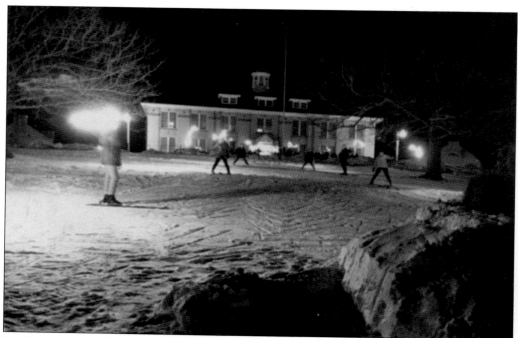

Students ski down the hill from present-day Frisbie Hall. Steep hills around the Old Quad were used for skiing for decades, until the Frederic R. Bennett Recreation Area and Ski Lodge opened in the mid-1960s.

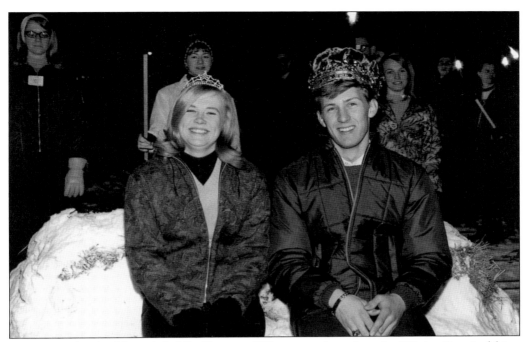

Douglas Foland ('66) and Ovidia Hansen ('66) were selected as the Winter Carnival king and queen. The event, held every February, included various winter sports, a school dance, and ice- and snow-sculpture competitions.

The Frederic R. Bennett Recreation Area and Ski Lodge is seen around the time of its opening in 1968. A short walk from the main college campus, just off State Route 10, the recreational area and lodge offered a new location for cross-country and downhill skiing, snowshoeing, and sledding.

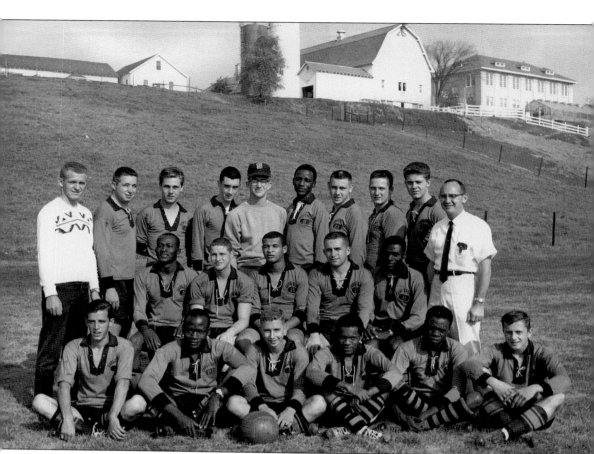

The first soccer team at New York State School of Agriculture and Technology at Cobleskill was formed in 1962, with the help of dairy science professor Bob McGuire. Six of the original members were of Kenyan descent and came to Cobleskill as international students. McGuire noted that the Kenyans disliked wearing shoes during practice, but he required them to wear cleats during games. The team went on to win four of eight games that season.

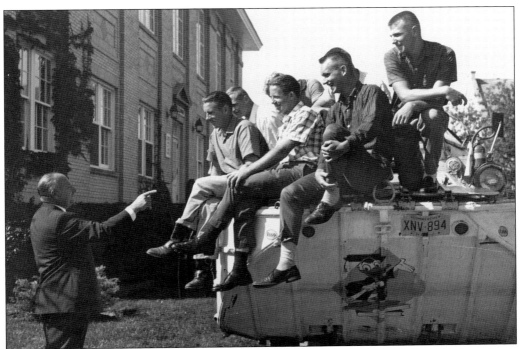

In 1961, Daniel Twomey ('60), along with Thomas Twomey ('60), Walter Kutrieb ('60), Robert Hinds ('60), and three other friends, obtained a surplus Army amphibian "Duck" and set out on a 27,000-mile goodwill mission through Latin America. Their ultimate goal was to reach their classmate and friend Pedro Recio ('60) in Colombia. During their journey, they found themselves marooned in the jungle and sought the help of Pres. John F. Kennedy. Their adventures are chronicled in the 2013 documentary *The Duck Diaries: A Cold War Quest for Friendship Across the Americas*.

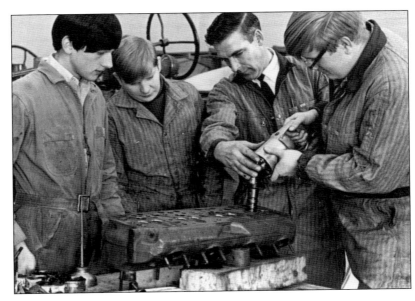

Gordon Walsh (second from right) was a beloved faculty member in agricultural engineering from 1966 to 1985. He instructed thousands of students at SUNY Cobleskill. He is seen here with three students in 1968.

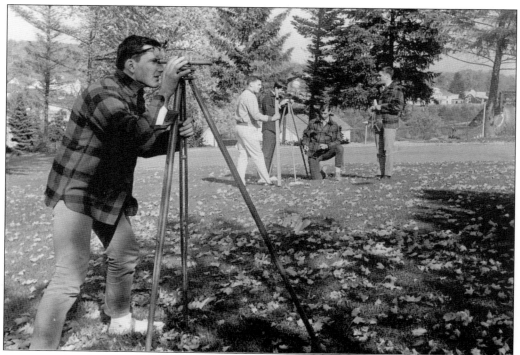

A group of students participate in a surveying class in 1962. These students enjoy a warm fall day behind the Home Economics building. SUNY Cobleskill once offered many courses in surveying and land management. Today, such courses are available to students through the agricultural engineering department.

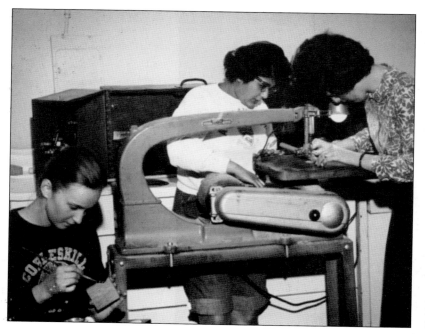

A group of students work with equipment to build wooden toys for the children in the campus nursery. Students leave SUNY Cobleskill with a variety of practical skills in preparation for careers.

The Home Economics building on the Old Quad is pictured here on a fall day in 1964, the first year the college's enrollment reached 1,000 students. Today, students continue to enjoy the views and open space afforded by the Old Quad.

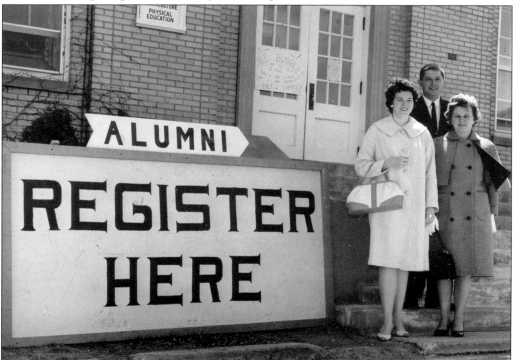

One of the annual highlights at SUNY Cobleskill is Alumni Weekend, more recently known as Homecoming.

Pictured is Draper Hall, a residence hall completed in 1966. Draper Hall, Dix Hall, and Pearson Hall collectively form what is now known as the "New Quad."

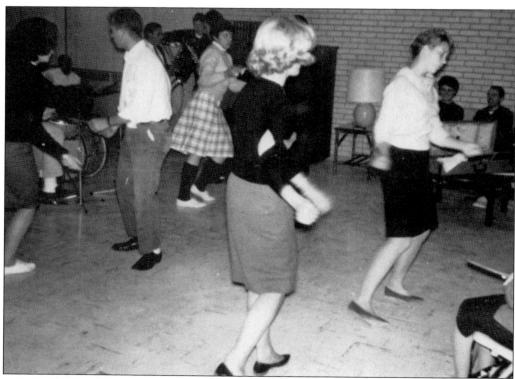

Residents of the newly built West Hall and East Hall gather for a Saturday night twist in 1962. In the preceding 10 years, enrollment had doubled, creating the need for student housing, a new dining hall, additional classrooms, and a library. These residence halls would later be renamed Vroman Hall and Wieting Hall. Prentice Dining Hall was completed in 1963, and Wheeler Hall opened in 1964, facilitating the additional classroom and library space.

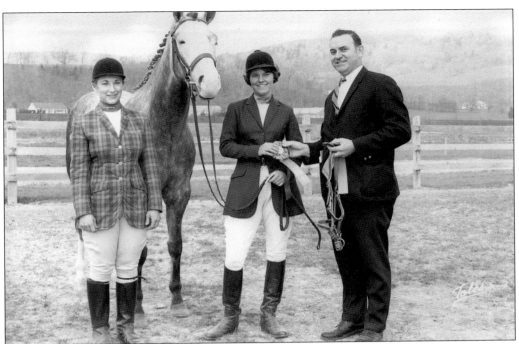

Patricia Johnson ('70, left) and Karan Gridley ('70, center) receive awards from faculty member Walter "Jack" Clark during the Alumni Weekend Horse Show on May 3, 1969. Clark served as a dean and retired as director of development in 1985.

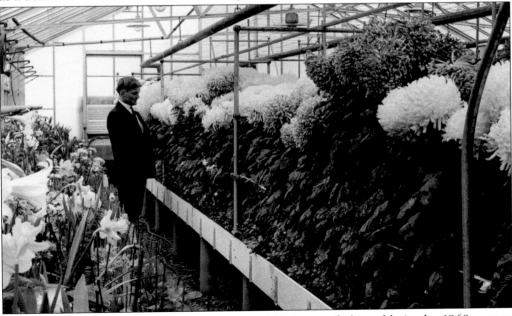

A student tends to a campus greenhouse in 1966. As was fashionable in the 1960s, many of the campus's male students wore a dark suit and tie, even to class. In 1966, Walton A. Brown became the college's seventh president. To this day, he remains its longest-serving president (1966–1985).

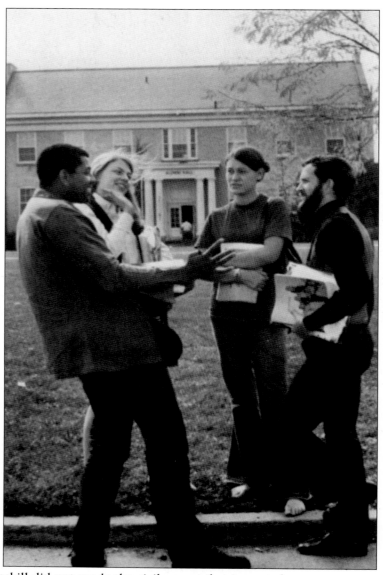

SUNY Cobleskill did not evade the civil unrest that impacted campuses across the nation in 1970, taking on the form of demonstrations about race, discipline, and the Vietnam War. Students held sit-ins around the flagpoles in front of Knapp Hall and participated in a march downtown. The summer 1970 edition of *Cobleskill Alumni News* addressed concerns of the day: "The College was no exception in reacting to the Kent State incident—when a group of students—supported silently by a few faculty—lowered the flag to half-mast. Another group—forcibly aided by other faculty—raised the flag to full staff. The threat of continued repetition touched off a petition demanding lowering of flag and cancellation of classes for a day's teach-in. A day of seminars on such topics as apathy, women's liberation, students' rights, US Foreign Policy, drugs and Vietnam brought both groups in vocal confrontation with goals practically the same, but means of achieving goals different. An evening march through town with factions united appeared to bring the day to a close with plans for further constructive meetings by students."

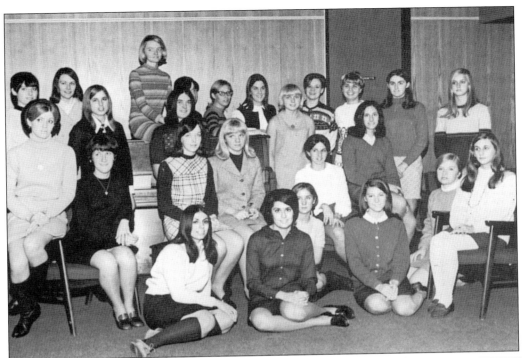

The Women's Student Government Association is pictured here in 1969. The association's primary purpose was to promote a spirit of unity among all women students by establishing rules of conduct. Although it had been a fixture on campus for several decades, it was disbanded in the early 1970s in favor of a more inclusive Student Government Association chapter. The position of dean of women was held by Ruby Doane.

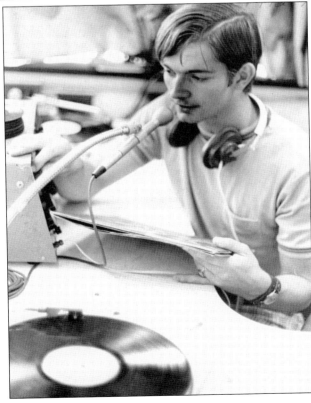

The WCOB radio station was active for several years until 1989. The station's AM signal reached only as far as the residence halls. In addition to current music, the station provided students with campus information and downtown business promotions. In 1986, the station moved from Bouck Hall to its final home in Brickyard Point.

THIS IS YOUR COLLEGE

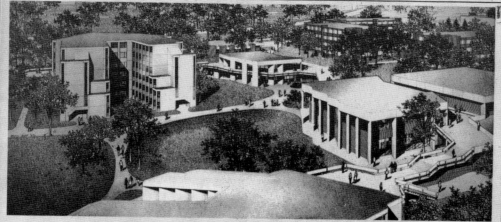

Master Plan Development . . . New Facilities included in the State University Master Plan for the College at Cobleskill.

Facilities - The Here, The Now, The Future

In a fall 1970 alumni news publication, the facilities program coordinator, Albie Harris, outlined the enrollment management plan and the additional facilities intended to support the growing campus. "A dining hall seating 500 students as well as additional food service administration facilities, five dormitories housing 1,034 students, and a recreation building to satisfy, somewhat, the needs of our students, is under construction with completion date in two phases: July 1971 and December 1971. In addition, under construction is a new infirmary to be completed by December of 1970." Accompanying this article is the sketch shown here, which depicts Champlin Hall, Fake Hall, Ten Eyck Hall, Parsons Hall, Porter Hall, Davis Hall, Brickyard Point, and the Beard Wellness Center, all referred to in this article.

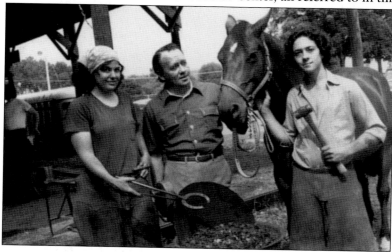

Students work alongside farriers, learning the art of horseshoeing during a 1974 equine seminar.

From the late 1960s and into the 1970s, freshmen were given caps at orientation to wear during their first week on campus. This alerted upperclassmen to ask questions about their experiences and to offer advice. Today, T-shirts given to freshmen during orientation serve a similar purpose.

Van Wagenen Library was built in the fall of 1973. Here, students, faculty, and staff form a human line between Wheeler Hall and the new library to expeditiously move books into the new space.

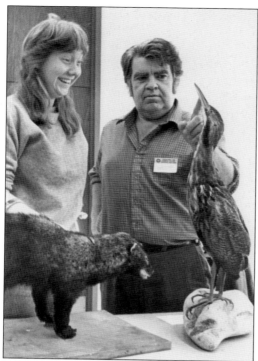

Dr. Robert "Doc" MacWatters, instrumental in initiating SUNY Cobleskill's fisheries and wildlife programs, is pictured with a lab student in the 1970s. Fisheries, wildlife, and environmental science are thriving programs, housed in the Center for Agriculture and Natural Resources. A long-standing tradition, the Fisheries and Wildlife Festival is held each spring, offering free demonstrations, live animals, and hands-on activities to community members.

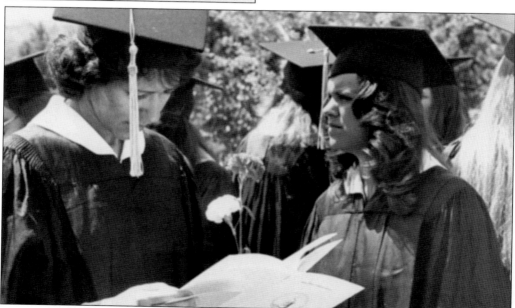

The summer 1970 edition of *Cobleskill Alumni News* addressed concerns of the day. "Any Disruptions at Commencement?" was answered: "The ceremony attended by some 2000 persons in Bouck Hall was without interruptive incident. . . . Several students wore white arm bands, a few assumed the stance of Black Power, others wore peace emblems." Following the ceremony, congressman and commencement speaker Hamilton Fish Jr. discussed philosophy with the faculty.

An animal husbandry class is seen here in 1976. As remains true today, animal science students at SUNY Cobleskill learn not only about livestock and dairy animals, but they experience practical learning while working with companion animals as well. Canine management and training classes are currently popular at the college.

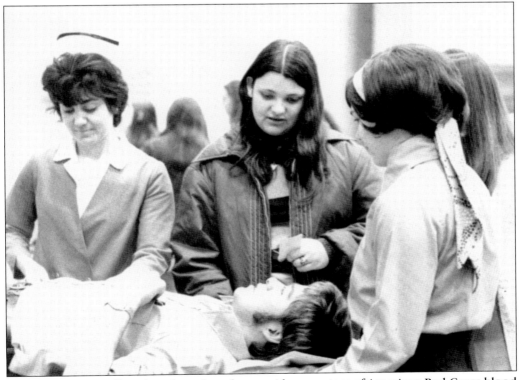

College faculty, staff, and students have been avid supporters of American Red Cross blood drives. Campus blood drives started in the 1960s and continue today, yielding the highest participation rate in the SUNY system in recent years. In recognition of this, several SUNY Cobleskill students have received American Red Cross scholarships.

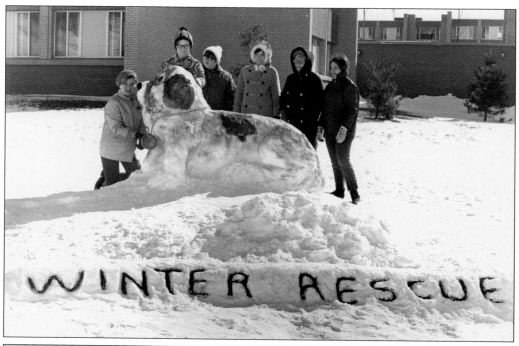

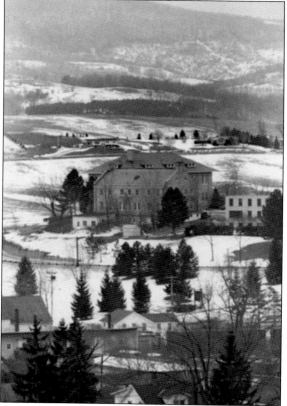

Winter Carnival was a long-standing tradition at SUNY Cobleskill, held each year in February throughout the early and mid-20th century. Carnival activities included a school dance, snow- and ice-sculpture competitions, winter sports, and the crowning of Winter Carnival king and queen.

A winter photograph of SUNY Cobleskill and the surrounding mountains, taken from the village, is reminiscent of the alma mater. "In the midst of scenic valleys, high upon the hill, stands our noble alma mater—dear old Cobleskill. Loyal ever be our spirit; and 'twill always be, Cobleskill our alma mater. Hail! All hail to thee! To our honored alma mater, hearts that beat so true. Pledge allegiance now and ever, Cobleskill to you."

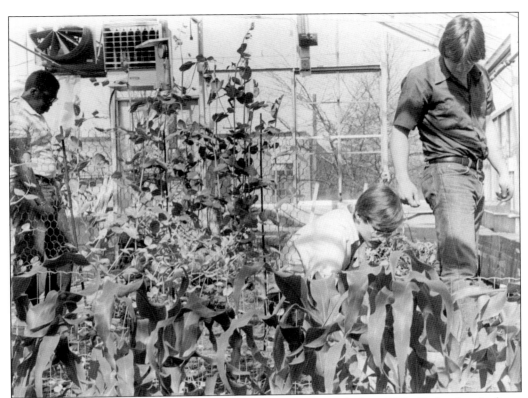

Students tend to greenhouse plants for a horticulture class in the late 1970s. Today, horticulture students have the opportunity to learn in high tunnels, state-of-the-art greenhouses, and aquaponic facilities, which combine both fish and plant production systems.

The college held a student vote for the design of a campus sculpture to be installed in front of Bouck Hall, the focal point of Bicentennial Mall, just in time for the nation's 200th birthday in 1976. Students chose the "Rolling Hills," which are now located on the east end of campus near State Route 7.

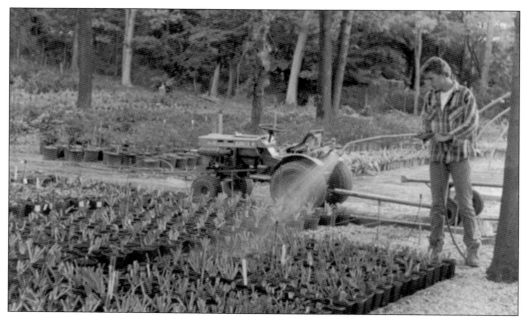

A student waters campus nursery stock in 1978. In the 1970s, the student population reached nearly 2,600, and the faculty devoted much of its time to modernization and adoption of novel teaching methods and new courses. In agriculture, for example, the number of course offerings increased from 60 to 109; in business, the increase was from 38 to 62.

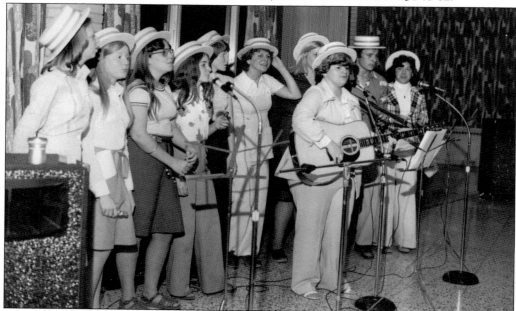

The Coby Singers entertain at an alumni banquet in Prentice Hall in the spring of 1977. The singer in the center is Cherie Stevens, who worked for more than 35 years supporting student activities, campus programming, and extended learning. She also directed "Pearson Presents," a campus-wide entertainment showcase for 25 years; advised the Yearbook Club for 24 years; and directed more than 80 campus musicals and plays.

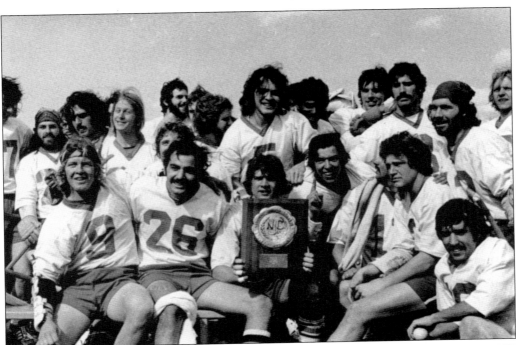

The college has had a lacrosse team since 1973. It currently plays in the NCAA Division III. The team played in the national lacrosse championship in 1976, 1978, and 1979. The 1976 team is pictured here.

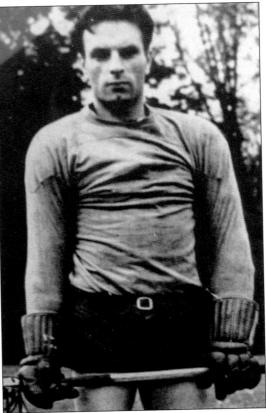

Albert "Nick" Iorio was a longtime friend and colleague at SUNY Cobleskill. Hired by the athletic department in 1949, Iorio went on to serve as dean of students until he retired in 1983. He was credited with coaching the men's lacrosse team to eight national championships. Pictured here in 1932, Iorio himself was named an All-American lacrosse player at Hobart College, where he earned his degree in history and American government. He also served as Cobleskill Village mayor.

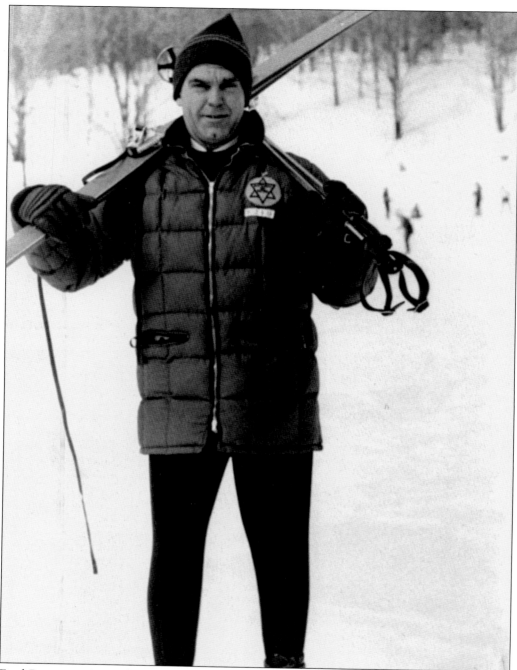

Fred Bennett, pictured here in the 1970s, was an athletic pioneer at SUNY Cobleskill. He came to the college as a track-and-field coach and was instrumental in the building of the ski lodge and recreation area that would be named in his honor. He coached Alpine and Nordic skiing, was advisor to the Outing Club, and later was appointed director of athletics.

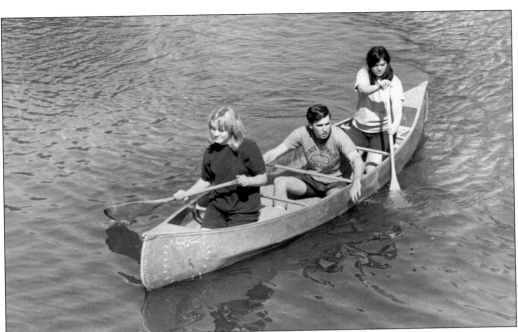

Students canoe on the pond located just down the hill from the ski lodge in 1978.

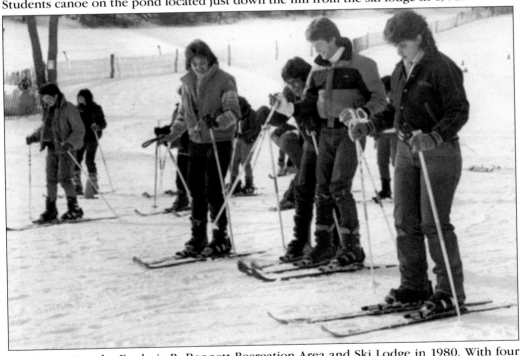

Students enjoy the Frederic R. Bennett Recreation Area and Ski Lodge in 1980. With four main downhill ski trails, a large pond, and a generous lodge, the area comprises nearly 30 acres and was a popular retreat from the main campus. As one of the few colleges in the Northeast to have ski facilities, SUNY Cobleskill hosted winter-sports competitions in the latter half of the 20th century.

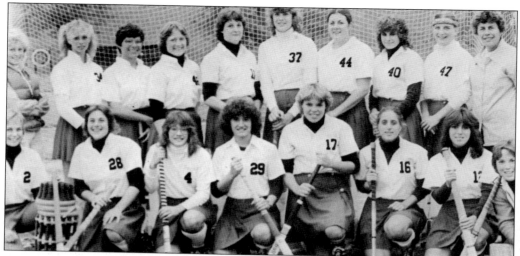

SUNY Cobleskill's field hockey team won the national championship for two-year colleges on November 6, 1982, beating favored Harford Community College 2-1. Following the game, coach Mary Danaher was named National Field Hockey Coach of the Year. Field hockey was disbanded in 1994. Other sports once played at SUNY Cobleskill include tennis, water polo, baseball, football, and wrestling.

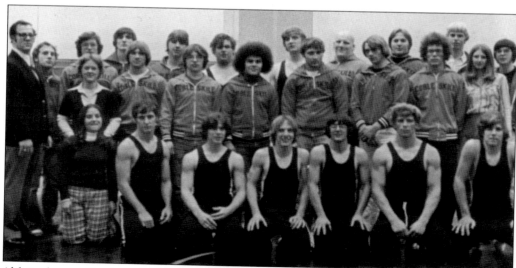

Although wrestling is no longer offered, SUNY Cobleskill NJCAA grapplers were respected on the mat, winning regional titles. Campus records show that the school's wrestlers competed at the national level and achieved All-American status. This 1977 team photograph includes coach Stan Nevins (far left), known for his commitment to wrestling and lacrosse.

These students work together to fit a cow for the annual Dairy Fashions Sale in 1981. This sale is the oldest annual event on campus and has generated more than $3.6 million in gross receipts in its nearly 40 years of operation. The sale is the longest-running collegiate student-group event of its kind in the United States.

In the 1970s and 1980s, downtown Cobleskill was a popular spot for students to spend evenings and weekends at village bars. In November 1974, seventeen-year-old freshman Katherine Kolodziej was walking back to campus from the popular bar hangout The Vault when she vanished. Then, 26 days later, her body was found a few miles away in the town of Richmondville. Her murder remains unsolved four decades later, and New York State Police continue to seek information related to their investigation.

Over the last 100 years, residential life has evolved from students cohabiting with local families in downtown homes and old carriage houses to living among academic peers. Recreational activities, ranging from happenings sponsored by formal organizations to impromptu horsing around, continue to have a place at SUNY Cobleskill. The National Minimum Drinking Age Act of 1984 transformed how campuses enforced alcohol policies and influenced faculty-student interaction outside the classroom.

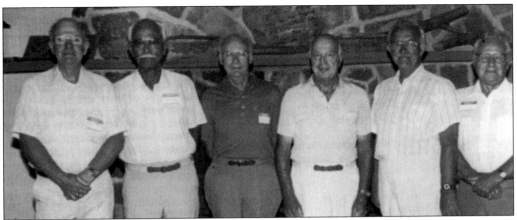

Since its opening in 1916, SUNY Cobleskill has been led by the following directors and presidents: Halsey B. Knapp, director (1916–1923); Lee W. Crittenden, director (1923–1936); Archie Champlin, director (1936–1942); Emmons D. Day, acting director (1942-1943); Carlton E. Wright, director (1943–1947); Ray Wheeler, director (1947–1961); Charles Gaffney, acting director (1961); Edward J. Sabol, president (1961–1966); Charles Gaffney, acting president (1966); Walton A. Brown, president (1966–1985); James Smoot, acting president (1985); Neal V. Robbins, president (1986–1991); Frank G. Pogue, acting president (1992); Kenneth E. Wing, president (1992–2002); William J. Murabito, interim president (2002–2003); Thomas Haas, president (2003–2006); Anne C. Myers, interim president (2006–2008); Donald P. Zingale, president (2008–2011); Candace S. Vancko, officer in charge (2011–2013); Debra H. Thatcher, acting president (2013–2015); and Marion Terenzio (appointed president 2015). In 1989, the living presidents gathered at the Ski Lodge for this photograph. They are, from left to right, Robbins, Smoot, Brown, Gaffney, Sabol, and Wright.

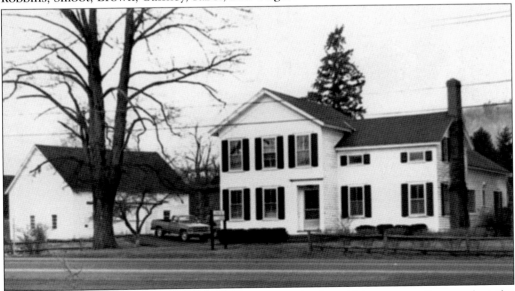

This is the first college president's house, built in the late 19th century. It served as the president's home until the early 1970s. It was demolished 20 years later, the result of deterioration beyond repair. The carriage house at left is currently used as the Schoharie Fresh location, a college-operated, countywide online farmers' market initiated in 2011.

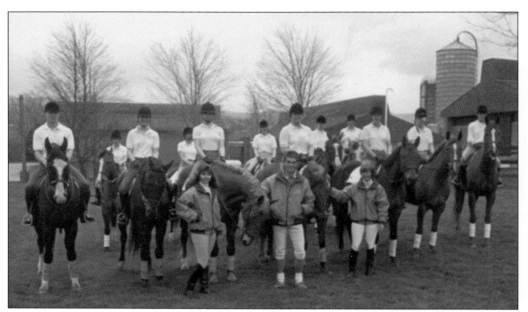

The equine team at SUNY Cobleskill has been a campus fixture for more than 30 years. Since 2010, the team has competed as part of NCAA Division III varsity sports. Students compete in both Western and English riding.

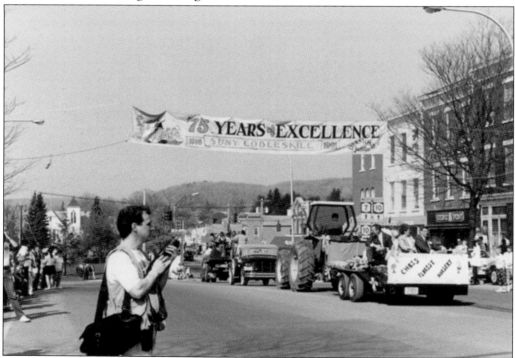

The college's 75th anniversary, or diamond jubilee, was celebrated in 1991. This photograph of the Alumni Parade was taken during Alumni Weekend of that year. Today, students still participate in many parades that flow through downtown Cobleskill.

Three

GROWING FORWARD
INTO THE SECOND CENTURY

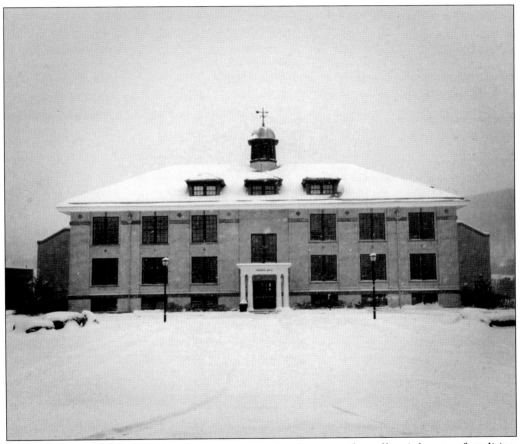

Frisbie Hall, remodeled in 2010, fosters a connection between the college's legacy of tradition and the progressive technology and accommodations it offers today. While proudly maintaining its original architectural framework, Frisbie Hall now consists of up-to-date classrooms, including an acoustically designed music room.

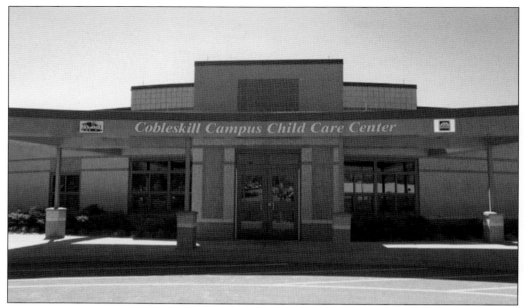

The Cobleskill Campus Child Care Center provides child-care services to members of the campus and larger community. Its innovative programming covers children from 6 weeks to 12 years of age. The center provides opportunity for early childhood students to get real-life experience in their field.

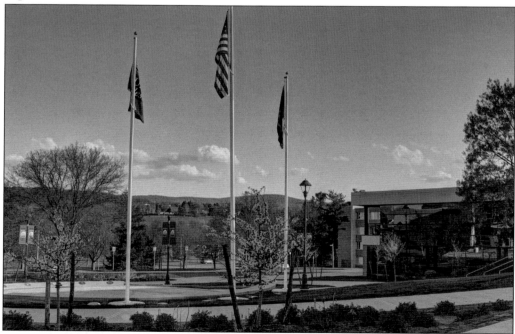

Opening in 2013, the Veteran's Plaza commemorates the service of men and women in the armed forces, reinforcing SUNY Cobleskill's commitment to offering academic opportunities and support to military personnel. The college has been named "military friendly" by *G.I. Jobs* magazine.

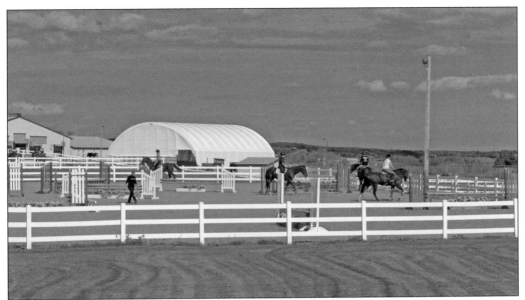

The SUNY Cobleskill Equestrian Center accommodates hands-on learning and enjoyment for the equestrian team, while creating informative experiences for members of the community. The nearby dairy complex can be seen in the left background.

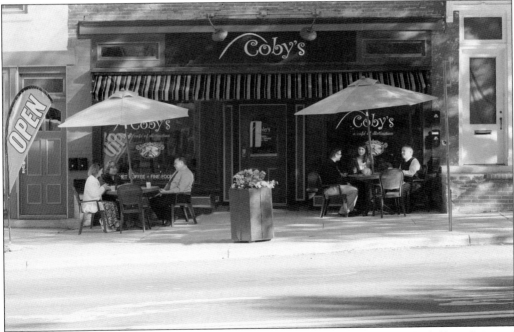

Coby's, a restaurant in downtown Cobleskill, exemplifies the SUNY Cobleskill tradition of "farm to table." It also allows students in culinary programs to practice a variety of skills in a working environment.

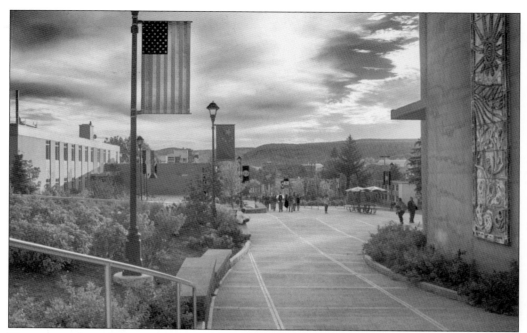

The campus beautification project, completed in 2013, improved walkways on the south side of campus and afforded new outdoor gathering places for students. Note the international flags in this photograph, which raise awareness about the multicultural student body and international exchange program.

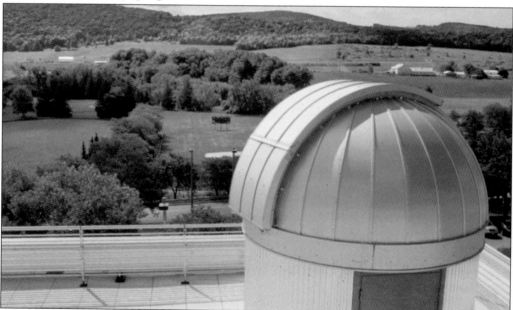

In 2011 and 2012, Wheeler Hall was extensively renovated, and a new laboratory addition was completed. The state-of-the-art labs mean that chances for cross-contamination are limited, as each science now has its own lab. This photograph was taken from the rooftop, where an operational observatory supplements the astronomy course and students' special projects.

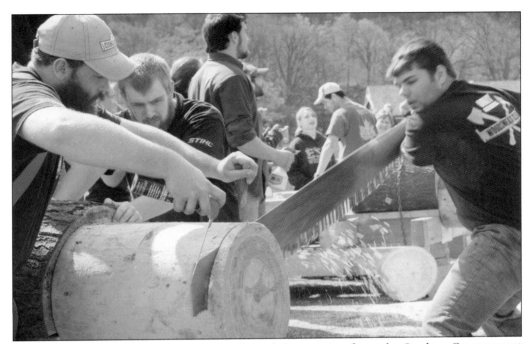

The college is now home to over 50 student clubs, ranging from the Student Government Association and honor societies (for associates and bachelor's students) to a chapter of Ducks Unlimited and the Woodsmen's Club (pictured). Not only do clubs allow for student bonding, exciting travel experiences, and an enhanced academic experience, but clubs are noted for their community service on and off campus.

Living on campus at SUNY Cobleskill provides students with the opportunity to meet new friends and thrive within the campus community, while growing both personally and academically in a safe and fun environment. Students can develop their home-away-from-home in a residence tailored to their needs, ranging from a first-year experience to upperclass living/learning.

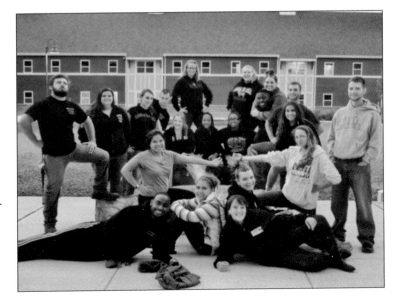

The $50 million Center for Agriculture and Natural Resources, which opened its doors in 2014, is an expansive building that houses the animal science, plant science, and fisheries and wildlife and environmental science programs, as well as many agricultural courses. With new fish hatcheries, meat-processing labs, and a tropical conservatory that is open to the community, the center is an outstanding example of SUNY Cobleskill's achievements and ambitions.

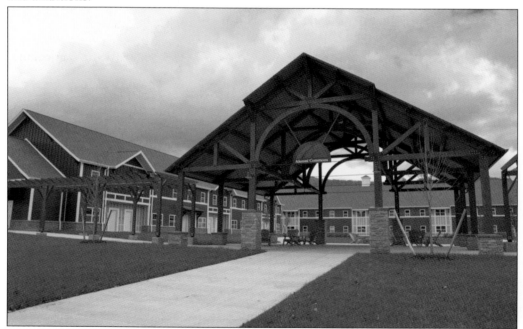

The Alumni Commons residential housing complex represents a new frontier in on-campus living for SUNY Cobleskill students. Opening in 2014, it is the result of a unique partnership between the college and the Alumni Association. The Alumni Commons offers suite and townhouse-style living for upperclassmen, as well as a common area for outdoor gatherings.

BIBLIOGRAPHY

Ashworth, Freeman. *A History of Cobleskill College.* Cobleskill, NY: 2009.

Cobleskill Alumni News. Cobleskill, NY: SUNY Cobleskill. Summer 1970.

"Facilities—The Here, The Now, The Future." *Cobleskill Alumni News* XXVIII (Fall 1970): 1.

Fleishman, Paul. *Reflections at 75.* Albany, NY: Fort Orange, Inc., 1990.

New York State School of Agriculture. *Catalogue and Announcement, Agriculture, Home Making, Teacher Training.* Seventeenth Annual Catalog ed. Albany: J.B. Lyon, Printers, 1932.

SUNY Cobleskill Magazine. Cobleskill, NY: SUNY Cobleskill, 2001–2008.

The Voice Yearbook. Cobleskill, NY: SUNY Cobleskill, 1920–1995.

The Voice. 1st ed. Vol. III. Cobleskill, NY: Students of the New York State School of Agriculture, 1923.

DISCOVER THOUSANDS OF LOCAL HISTORY BOOKS FEATURING MILLIONS OF VINTAGE IMAGES

Arcadia Publishing, the leading local history publisher in the United States, is committed to making history accessible and meaningful through publishing books that celebrate and preserve the heritage of America's people and places.

Find more books like this at
www.arcadiapublishing.com

Search for your hometown history, your old stomping grounds, and even your favorite sports team.